# Elegant Pie

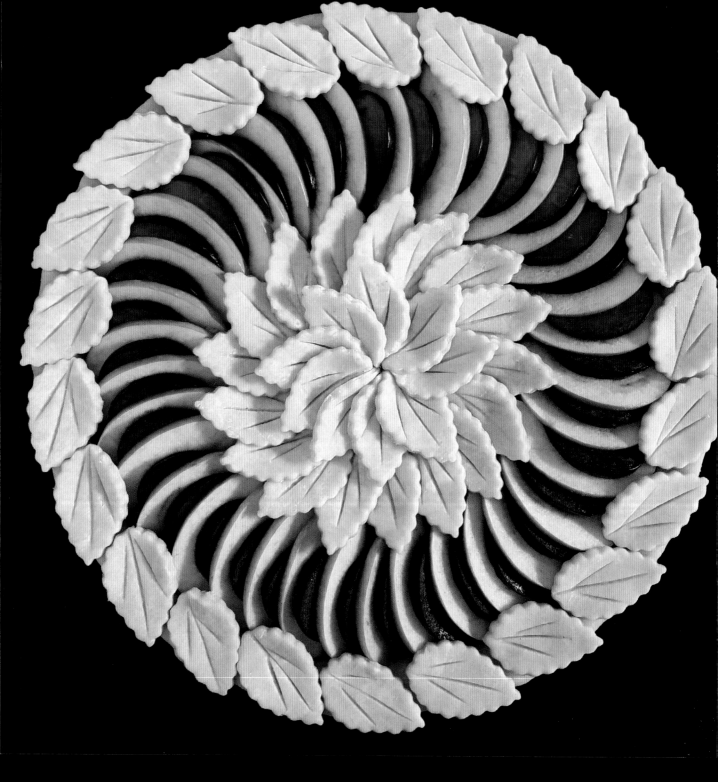

# Elegant Pie

TRANSFORM YOUR FAVORITE PIES INTO WORKS OF ART

Karin Pfeiff-Boschek

Andrews McMeel
PUBLISHING®

*To my loyal companions, Bruce and Andor*

# Elegant Pie

Andrews McMeel Publishing
a division of Andrews McMeel Universal
1130 Walnut Street, Kansas City, Missouri 64106

www.andrewsmcmeel.com

19 20 21 22 23 TEN 10 9 8 7 6 5 4 3 2 1

ISBN: 978-1-5248-5329-7

Library of Congress Control Number: 2019940628

Editor: Jean Z. Lucas
Art Director/Designer: Holly Swayne
Production Editor: Elizabeth A. Garcia
Production Manager: Carol Coe

**ATTENTION: SCHOOLS AND BUSINESSES**
Andrews McMeel books are available at quantity discounts with bulk purchase for
educational, business, or sales promotional use. For information, please e-mail the
Andrews McMeel Publishing Special Sales Department: specialsales@amuniversal.com.

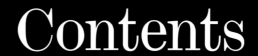

# Contents

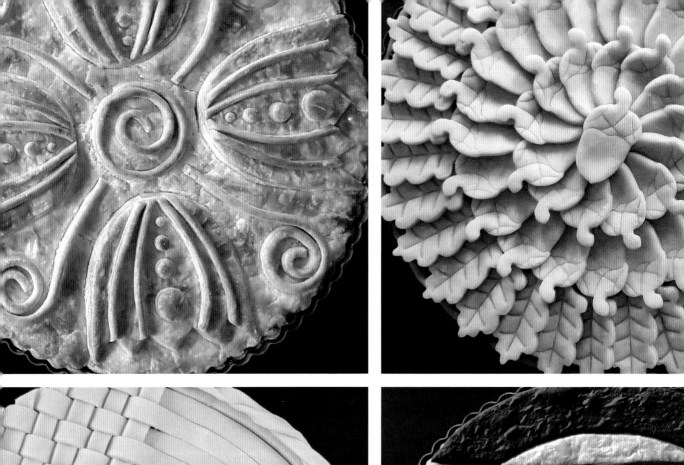

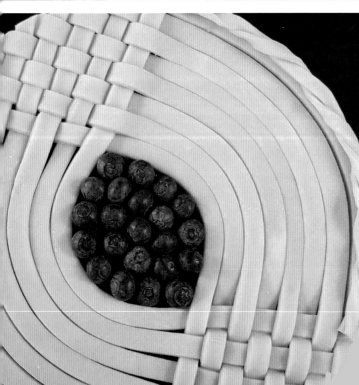

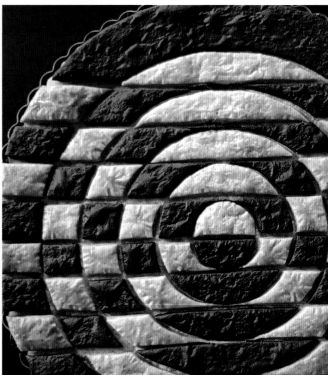

# Introduction

Although I have been baking all kinds of pastries much of my life, it was just two years ago that I had the notion to add artistic decorations to my pies. Since pies are a favorite comfort food in many countries, they seemed well worth the effort to make more aesthetically pleasing. Having been active for twenty years in the field of textile design, I had plenty of ideas on how to embellish all kinds of creations, but pie dough offered a new and unexplored challenge. My first efforts received so much praise from friends and guests that I felt confident enough to upload a picture to my Instagram account. To my delight, that first picture received many more likes than any other picture on my account at that time, giving me the confidence to experiment further. Six months later, one of my pies on Instagram attracted the attention of Martha Stewart, who wrote that I had turned pie crust decorating into an art form, words of praise that cemented my conviction that artistic pie decoration was a worthwhile endeavor.

Many of my textile creations were based on geometric patterns, and these provided inspiration for similar designs in my pie decoration. I began to gradually understand the characteristics and limitations inherent in working with pie dough, and my creations became more creative and complex. I was determined to avoid becoming entrenched in one style, so instead I experimented with many different colors; abstract geometric shapes; and familiar objects such as flowers, stars, leaves, and hearts. I found inspiration in many places, including nature, historical and traditional designs, and everyday objects. One crust was even inspired by a manhole cover I saw on the street in front of our home!

It goes without saying that not all designs were completely successful, and I had my share of mishaps.

I made one beautiful pie with many cutout flowers and other decorations and then decided the edge needed a special treatment, so I made a long braid and placed it around the edge of the pie, carefully applying egg wash to secure it in place. I then put it in the oven, and after about ten minutes, I looked to see the end of the braid beginning to slip off the pie. I opened the oven door only to watch the rest of the braid slither down onto the oven rack, leaving the edge of the pie unadorned. I quickly pulled the pie out of the oven and carefully embossed the edge with a fork, rescuing it and giving it a finished appearance. Just as with cooking in general, things are bound to go wrong when baking a pie, but with a bit of quick thinking and imagination, it is usually possible to save the day. Ironically, this first mishap repeated itself when I used a row of hearts around the edge of another pie. The hearts were too close to the edge, and as the pie began to bake, they all slipped off onto the oven rack. So now I don't make the mistake of putting decorations too close to the edge of the pie anymore.

One property of pie dough that requires some forethought is its tendency to shrink when baking. The most attractive unbaked pie can lose its beauty in the oven if care is not taken. Regardless of how good a pie looks before baking, it's not finished until it comes out of the oven. No one would serve or eat an unbaked pie. Compensating for shrinkage requires planning; however, a certain degree of uncertainty still remains. Optimizing the dough by using as little water as possible will reduce the amount of shrinkage, but it's not possible to eliminate this tendency altogether. The designs shown in this book have all been tested repeatedly and can serve as models for experimenting with your own patterns. If the techniques are followed, there shouldn't be any problems with shrinkage, and the results will be almost certain.

I've included twenty-five pies in this book based on the variety of methods used for their preparation. Making a few of these will provide practice and experience in freehand cutting, use of pie or cookie cutters, braiding, and other techniques.

It is my sincere hope that you will find inspiration in the designs shown in this book and that you will have as much fun as I have turning pies into artistic creations. Making the pie beautiful does not detract from its delicious flavor and can only bring increased pleasure to your table or afternoon coffee hour. I wish you success and enjoyment in your efforts.

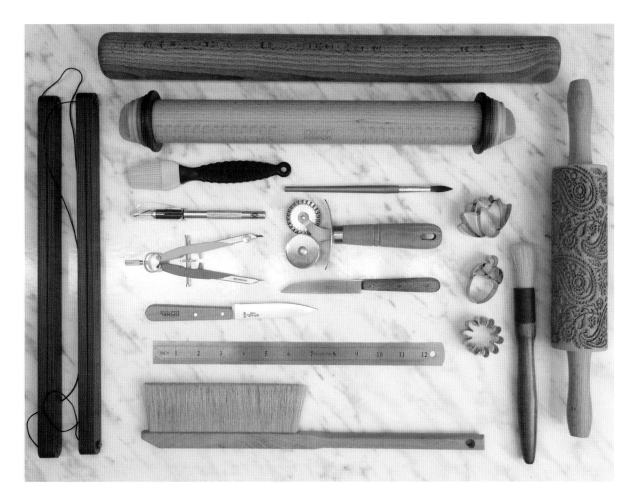

## USEFUL TOOLS AND EQUIPMENT
## FOR PIE MAKING AND DECORATION

The only tools and equipment that are absolutely necessary for pie decoration are the same that are necessary for making a simple pie, plus a refrigerator or freezer and a sharp knife. Your kitchen is probably already equipped with bowls, measuring cups, measuring spoons, and other basic equipment. The list of additional tools and accessories that may be useful for decoration techniques is nearly unlimited, but, to begin with, the following minimum list is quite adequate:

Work area and surface
Rolling pin
Scalpel or craft knife
Rolling cutter
Cookie (dough) cutters (various shapes and sizes)
Ruler
Pastry brushes
Pie pans
Borderless pastry lifters or cake lifters
Oven
Refrigerator and freezer
Pastry scraper
Hot pads
Cooling racks

These basic tools and equipment are shown here and deserve some consideration:

### WORK AREA AND SURFACE

The cooler the kitchen, the better. A very warm kitchen will be an obstacle to working with pie dough, requiring that the dough be returned to the refrigerator very often during the shaping process. A heavy marble slab as a working surface will stay cooler longer as the kitchen warms up, but it will eventually warm up and then will take a longer time to cool back down. If possible, you might consider doing the decoration work in another, cooler room. As to the work surface itself, this is a matter of personal choice.

I work on a hardwood countertop with almost a square yard of space. Some pie makers prefer marble or stone, and others work on a pastry cloth. These are all suitable for rolling out the dough, but when cutting with a sharp knife, you'll want a surface that won't suffer when pressing down on the knife. A cutting mat makes an ideal surface for cutting and layout work. A flat and smooth cutting board of wood or nylon also works well.

### ROLLING PIN

The type of material—wood, metal, plastic, or marble, with or without handles—is a matter of personal preference. I use a simple beech wood cylindrical pin about 2.5 inches (6 cm) in diameter and 12 inches (30 cm) long. If your work area is very warm, a metal or marble rolling pin that can be cooled in the refrigerator and retains the cold may be an advantage. For fine decorative ornaments that will be cut out by hand or with metal or plastic cutters, it is essential that the dough be rolled out smoothly, evenly, and thinly. For this, I use a rolling pin with rings on the ends that assure an even dough thickness (see image on page 3). I usually roll out dough for this purpose to ⅛ inch (3 mm) thick. Rings are available to fit various diameters of rolling pins, too. Alternatively, so-called pastry rulers of different thicknesses are available in plastic or wood. These can be used with a normal rolling pin and assure equal thickness throughout. Whatever rolling pin you use, make certain it is

spotlessly clean and lightly floured before bringing it into contact with the dough.

### SCALPEL OR CRAFT KNIFE

A very sharp paring knife can be used, especially if the blade is not too wide. The thinner and sharper the blade, the better, since a thin and sharp blade gives the most accurate and most smoothly cut edge. A better solution is a surgical scalpel or a craft knife with a replaceable blade. Since the tips of these blades are very thin, it's possible to cut very tight curves and corners with them. I use a relatively inexpensive knife that can be purchased online or at a craft store. If the blade gets damaged, it can be quickly and inexpensively replaced with a new one.

### ROLLING CUTTER

These are available in a variety of shapes and sizes and are useful for making long cuts along a straight edge. The cutting wheel should have a thin, sharp edge. An adjustable rolling cutter with up to six wheels makes easy work of cutting strips. A lattice cutter can create interesting and accurate lattice designs.

### COOKIE (DOUGH) CUTTERS

These are available in an almost endless variety of shapes and sizes, ranging from complicated patterns such as automobiles and airplanes to simpler designs such as flowers, fruits and vegetables, stars, and hearts. Finally, and most useful, are various geometric figures such as circles, squares, rectangles, triangles, and curves. Cutters are made of stainless steel, chromed steel, or plastic and may have "ejectors," spring-loaded plungers that push the cutout piece of dough out of the cutter, perhaps even embossing the piece with leaf veins or other markings. Geometric cutters are often found in practical sets of different sizes. It should be noted that very fine, complex, or filigree shapes may not be usable with pie dough, so it is best to stick with somewhat larger and simpler structures.

### RULER

A stainless-steel ruler, at least 12 inches (30 cm) long, is necessary for making long, straight cuts. A simple straight edge will also work, but having the dimensions in inches and/or centimeters is useful.

### PASTRY BRUSHES

A 1-inch (2.5-cm) brush is perfect for applying an egg wash before baking or as a "glue" to hold ornamental pieces together. I use a silicone brush with very soft bristles. It is lightweight and can be cleaned in the dishwasher. A wider brush is useful for larger areas, and a few small artist-style paintbrushes are wonderful for working in small areas, either with egg wash or for applying coloring agents. In addition, I have a round camel-hair brush about 1 inch (2.5 cm) in diameter that I use for removing excess flour from dough surfaces. Finally, a so-called flour bench brush is practical for sweeping excess flour off of the working surface.

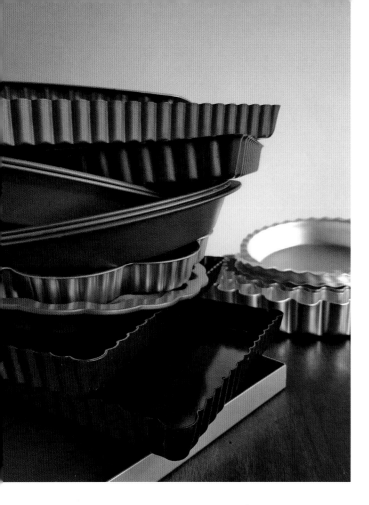

## PIE PANS

Glass, ceramic, aluminum, or steel? This is a somewhat contentious subject. Many bakers have opinions and preferences on the ideal material in which to bake a pie. I can tell you my choice, but if you already have a preference, you should use the pan of your choice. As far as thermal conductivity is concerned, the winner is aluminum, followed by steel, ceramic, and glass.

Glass is a very poor thermal conductor; in fact, it is actually an insulator. However, since it's transparent, and radiant energy can pass through, it's difficult to compare its effect on baking with other materials. Ceramic material is also a poor thermal conductor, but some ceramic pans are so attractive that one might accept the disadvantage for the sake of appearance. That said, my favorite pie pans are made of nonstick steel. If I use loose-bottom pans, I am careful to keep the bottom crust intact so the filling cannot leak through to the pan bottom and out around the edge.

Perhaps as important as the material is the size of the pan. For decoration, it can be said that the larger the pan, the better, because you have more room for embellishments. I generally use a 10-inch (25-cm) or 13-inch (33-cm) flat pan. The 1-inch-deep (2.5 cm) flat pan reduces both the volume of the filling and the baking time for the bottom crust. Of course, if you need a larger pie, you can also use a deeper pan or make a so-called slab pie in a large rectangular form. Square pies are also very attractive, and there are a number of square pie pans available.

When choosing a pan, you must consider the edge. If you wish to make a crimped crust, an extended edge is very practical. If the pan has a thin metal fluted edge, such as a tart pan with no lip, it's generally best to simply place the top crust on the filled bottom crust and not try to seal the edge. This has the advantage that filling and steam can escape around the edge, making steam slits unnecessary.

## BORDERLESS PASTRY LIFTER
## OR CAKE LIFTER

These are not generally used for baking but rather for handling rolled-out dough and cutout ornaments. Most useful are 12.5-inch (32-cm) cake lifters or pizza peel round metal sheets, with or without handles. Whether round, square, or rectangular, aluminum or steel, these sheets must be thin, less than 5⁄64 inch (2 mm), and without a raised edge.

## OVEN

While any oven can be used, it is important to know the quirks and characteristics of your own oven. Some ovens tend to brown unevenly, and this can be compensated for by rotating the pie once or twice during baking. Larger ovens may bake more evenly.

Temperature control is very important, and a good, reliable oven thermometer will give a much more accurate indication of temperature than the scale on the oven thermostat. For proper browning of the crust, it's best to use conventional top and bottom heat, rather than a fan-assisted convection oven. It's generally a good idea to bake pies on the bottom rack position in order to assure that the bottom crust gets done before the top crust gets burned. It may still be necessary to cover the top crust with aluminum foil if it begins to brown too much. The bottom crust will not be properly baked if you reduce the baking time too greatly. An oven with a glass window in the door is an advantage because it's necessary to watch the pie bake for the first ten minutes. If the oven has no window, you can carefully open the door for a few seconds and check the baking process. Keeping the window clean with oven cleaner is important so that you can see inside well. Speaking of cleanliness, keeping the oven clean and free of grease is definitely essential to avoid fires and copious amounts of smoke. The bottom drip tray should be covered with fresh aluminum foil whenever necessary. Foil that is covered with grease or fruit drippings will be a massive source of smoke.

The first oven I used was a gas oven. These used to be very common, and although they have become less popular, there's no reason you can't get excellent results in them. I don't have a lot of experience with gas ovens for pie decoration, as I currently use a self-contained independent electric oven, and even

most modern gas ranges now have electric ovens. If you're used to using gas, you'll probably have enough experience to know how best to bake a pie in it, or you can read about others' experiences. The "gas mark" is not a very accurate description of temperature, and a good oven thermometer is more than important here. You might try placing the thermometer in different areas of the oven to get an idea of the heat distribution. In my limited experience with gas ovens, they are particularly prone to having hot spots and cool spots, so rotating the pie during the baking time will be necessary.

Many modern ovens offer fan-assisted or convection baking. This heating system uses a fan or fans that blow over a heating element or elements and circulate hot air throughout the oven. This is in contrast to the mixed hot-air and radiant heat of a standard oven with top and bottom heat. Newer convection ovens may even have radiant heaters on the top and bottom to provide more conventional heat patterns; however, this goes beyond the scope of this book. There are many good sources of information about modern baking ovens on the Internet. Although my ovens have these capabilities, I have never felt comfortable using them. My first impression was that the crust gets somewhat drier and crumblier with convection heat, so I have stuck with conventional top and bottom heating. This is my own personal impression, and you may find the convection oven to your liking.

In a standard oven with top and bottom heating elements, both elements are used during preheating, but usually only the bottom element is on during baking. This makes sense since the heat rises in the metal box of the oven, and, consequently, the top is always hottest anyway. This can result in the top of baked goods getting baked before the bottom is even warmed. For this reason, ovens have baking racks that can be moved from top to middle or bottom in the oven. Choosing the right position for baking is important and will be discussed in the section on baking (see page 32).

## REFRIGERATOR AND FREEZER

Pie dough quickly loses its shape and consistency at room temperature. In addition, the butter or shortening begins to melt and blend in with the flour, leaving a homogenous mass that bakes up like plaster of paris. For this reason, it's essential to cool the dough regularly when making decorative patterns. It may be necessary to place the rolled-out dough and/or decorative elements back in the refrigerator many times while working.

The same is true immediately after making the dough, which must be refrigerated for at least an hour or overnight so that the moisture can permeate and equalize throughout the dough.

In addition, the finished pie can be placed in the refrigerator overnight before baking the next day. This is a big bonus for those of us who have day jobs

and have only a few hours in the evening to work on a pie. I often finish decorating a pie late at night and then put it in the refrigerator and bake the next day.

A freezer offers the possibility of quickly cooling the rolled-out dough, ornaments, or even the finished pie. Once prepared, the dough can be wrapped tightly in plastic wrap or placed in a resealable plastic freezer bag, frozen, and kept for up to two weeks. Even a whole top crust can be frozen and kept until needed. If possible, a drawer in an upright freezer or a basket in a chest-type freezer can be kept available for quick use when preparing a pie.

## PASTRY SCRAPER

Made of metal or plastic, these are essential for moving dough or small decorations and for cleaning up the work area. I use a simple scraper made of plastic.

## HOT PADS

Either good, insulated hot pads or long-sleeve oven gloves should always be at hand for retrieving the pie from the hot oven.

## COOLING RACKS

Once the pie is removed from the oven, you'll need a place for it to cool. Cooling racks come in many different sizes and qualities. A high-quality 12-inch (30-cm) stainless-steel round rack is a good investment and will serve you well, even as a background for photographing your work of art.

## ADDITIONAL TOOLS AND EQUIPMENT

There are additional handy devices you can also use for working with pie dough.

For preparation of the dough, a food processor or a stand mixer is an excellent investment. Alternatively, a hand pastry blender is an inexpensive improvement over the use of two knives or a fork. In the section on preparation of the dough, I explain why I prefer to use a stand mixer or food processor (see page 10).

A flour duster or sieve is helpful in spreading an even amount of flour on the work surface.

An inexpensive draftsman's compass is useful for marking circular cuts.

These are some of the tools that I use regularly and that are practical for the techniques described in this book. Oftentimes I will find some obscure instrument to be useful for a given design. My husband even gave me a set of cork borers used in the laboratory that I sometimes use for making small dots. There is no reason to limit yourself to any particular tools. The more imaginative and inventive you are, the more unique and original your designs will be.

# PREPARING AND WORKING WITH PÂTE BRISÉE PIE DOUGH

**KEEPING IT COLD IS THE KEY TO SUCCESS!**
In order to be suitable for use in decorative crusts, the pie dough must meet certain requirements. It must be soft and pliable but not fragile. It must stand up to multiple cooling cycles or freezing without becoming brittle, firm, or discolored, and it must be reproducible. Of course, it must also produce a flaky and delicious crust upon baking. I have experimented with a number of methods and formulations and have developed a simple recipe that is easy to make and meets all of these prerequisites. It's a variation of the recipe my husband inherited from his mother, who was a prize-winning pie baker in the Midwest. It also uses common ingredients available in most home kitchens.

In the end, I came up with a recipe that was noted in the *Washington Post*: "True to its name, this is about the flakiest pie crust we have tested in the WaPoFood Lab. Its tensile strength makes it especially good for the kind of intricate designs produced by its author, German baker and pie artist Karin Pfeiff-Boschek."

To save time and create superior reproducibility, I use a stand mixer or food processor to prepare the dough. However, I have also included manual methods, using just your fingers, a pastry cutter, two knives, or a fork. I cannot emphasize enough the importance of keeping the butter, water, egg, and final dough cold throughout the preparation, as well as cooling it in between steps when rolling, cutting, or otherwise working with it. If your kitchen is very warm, it may even be a good idea to place the flour, cutter, and mixing bowl you will be using in the refrigerator for half an hour before beginning to work. Heat is truly the enemy of pie dough (until it is baked in the oven, at least). My husband will testify that I have cool hands, but if your hands are very warm, you may want to hold them in cool water for a few minutes before you pat the dough together. You will be rewarded with a much flakier crust and dough that is easier to work with if you make sure to keep it cold throughout all the preparation steps.

At the end of this section are modifications or recipes to make various colored doughs by using naturally pigmented foodstuffs.

**INGREDIENTS AND MEASUREMENTS**
Every baker knows that the more accurately you can measure your ingredients, the more likely you'll have success in baking. For this reason, I recommend using a kitchen scale to measure the ingredients by weight. Even if you sift your flour consistently before measuring it in a cup, the actual mass (weight) of the flour will vary considerably. The same applies to liquid measurements. Using a standard glass measuring cup

I am providing the recipe for the dough that I use for my decorative pies. This all-butter recipe makes a delicious and flaky crust, and the dough is especially suitable for the creation of decorations and ornaments. If you are a seasoned pie baker and have been using your own recipe with success, you should definitely try it before changing recipes. You may find that your dough works just fine for these designs. I would steer away from whole-grain doughs and high-fat doughs, as these are really not suitable for decorative purposes.

can result in an error of more than 10 percent. I do understand, however, that seasoned bakers who have been using volume measurements all of their lives might not be as easily convinced of the necessity of weighing ingredients, so I also give the measurements in cups, tablespoons, teaspoons, and sticks of butter. My recipe for one batch of dough yields about 24 ounces (700 g), which is more than an ample amount to make a double-crust pie. I usually divide the batch into one-third and two-third amounts, using the smaller amount for the bottom crust. For complex designs, it may be necessary to use another half or two-thirds of a batch.

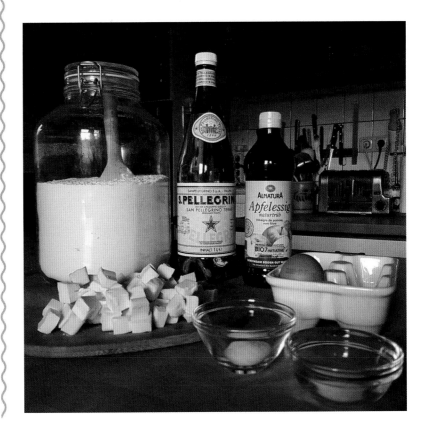

This is not a problem, as you can simply freeze the part you don't use and save it for up to two weeks (see page 17).

## Flour

I have experimented with a number of different types and brands of flour, and I'm convinced that the best results are obtained using unbleached all-purpose or plain white flour, usually milled from hard spring wheat with a protein content of about 12 percent. This is the most common flour found in supermarkets throughout the Western world. I have also experimented with commercial or homemade pastry flour with 10 percent protein, and the crust seems a bit lighter, but the dough is somewhat more difficult to work with, as it tears more easily when rolled out thin. This is even more pronounced with cake flour (8 percent protein). In my opinion, whole-grain flours are unsuitable for decorative pie crusts. They result in heavy, firm, or tough crusts, and they crack easily and are difficult to handle when cutting fine decorations. I don't have much experience using gluten-free flours for pie crust decoration, so you will have to experiment and see what works best for you.

Since conversion factors listed on the Internet and elsewhere vary greatly, I use my own conversion factor for flour, determined by sifting once and then resifting the sifted flour into a 1-cup dry measuring cup and leveling it off with a knife. This results in 140 grams per 1 cup. Therefore, the 350 grams used in my basic dough recipe come out to exactly 2½ cups. It must, however, be noted that different flours have different mass densities and different degrees of hydration, so some initial testing may well be required. A cup may be as little as 120 grams, so it's important to do some testing first. In fact, it would be useful to practice making dough a number of times in order to get a feel for the ingredients and the method to ensure successful reproducibility. Nothing is more frustrating than dough having a different consistency each time you make it.

## Butter

Here in Germany, all standard butter brands are very similar, as well as quite reliable and interchangeable. I generally use cultured, unsalted butter, adding salt to the recipe appropriately, but there is no reason not to use salted butter and simply adjust the seasoning. I understand that in some countries all butters are not the same, and I have seen mention of "European-type butter." I presume this is related to the amount of water in the butter, but I have no experience with "non-European" butters. I prefer cultured butter because it has a tangier flavor, but plain, uncultured, sweet butter will work just as well. You may need to do some experimentation or read about other bakers' experiences with different brands of butter on the Internet. Here again, if you are an experienced baker, you probably already know which butter you prefer.

## Eggs

I use one chicken egg per full batch of dough. It makes no difference what size the egg is because I measure the final amount of liquid, adding water to obtain the necessary amount. In our kitchen, we use only free-range organic eggs. The egg should be cold, directly out of the refrigerator.

## Vinegar

Since I use only a teaspoon (5 ml) of vinegar, any kind will work; however, I don't recommend balsamic vinegars, as they add a flavor that is not necessarily desirable. I generally use a simple white wine vinegar or apple cider vinegar.

## Water

Here in Europe almost everyone drinks carbonated mineral water, so every household has it on hand. I use it directly out of the refrigerator, usually drinking the rest of the bottle while I work. Carbonated water is not strictly necessary, but it does yield a lighter, flakier crust. If you don't have any or don't want to bother buying it, you can use ice-cold tap water, assuming your water has a good, clean taste. Adding a pinch of cream of tartar to tap water improves the flakiness of the crust because it reacts with the vinegar to produce carbon dioxide, just like the sparkling water. If your tap water has an unpleasant taste, you can buy a bottle of plain (or carbonated) drinking water and keep it in the refrigerator. Bad-tasting water usually does not yield a good-tasting crust.

## Salt and Sugar

I use fine granulated sea salt and plain white granulated sugar. There is no reason not to use plain table salt if that is what you normally use in the kitchen. Coarse or flaked sea salt or kosher salt can be used if you don't mind the crunchiness. For savory pies, just reduce or leave out the amount of sugar called for. You do not need to adjust the amount of flour if not using sugar.

# BASIC PIE DOUGH

**MAKES TWO (9 TO 13-INCH/23 TO 33-CM) PIE CRUSTS**

1 cup (2 sticks/200 g) cold, salted butter

1 medium or large egg

1 teaspoon apple cider vinegar or white wine vinegar

Ice-cold carbonated mineral water, or ice-cold tap water or still bottled water and a pinch of cream of tartar

2½ cups (350 g) all-purpose flour

1 teaspoon fine sea salt or table salt

1 teaspoon granulated sugar

### FOR MACHINE AND MANUAL METHODS

Begin by preparing the butter and the liquids. Place 2 sticks or measure out 1 cup (200 g) of cold butter on a cold board and use a knife to cube it into about ½-inch (1.25-cm) pieces. Place the butter back in the refrigerator or freezer.

Break the egg into a mug or other container with a volume of about 2 cups (500 ml). After quickly whisking, add the vinegar and then carefully add the cold carbonated water to make a total of 4½ ounces (135 ml). Mix well with a whisk or a fork. Place the container with the liquid back in the refrigerator.

### FOOD PROCESSOR METHOD

Once the butter and liquid ingredients are measured out and stored cold, you can make the dough. My food processor has variable speeds, which is of some advantage but is certainly not essential. The bowl, cutter, and lid must be clean and dry. Sift the flour into 1-cup and ½-cup dry measuring cups, for a total of 2½ cups (or weigh out 12 ounces/350 g), and add to the bowl. Add the salt and sugar, and run or pulse the machine for a few seconds to mix. If the kitchen and ingredients are very warm, place the bowl with ingredients in the refrigerator until chilled.

Add the cold butter to the flour mixture and pulse until the lumps of butter are about pea-sized, then turn off the machine. Have the liquid ready to add through the chute. Pulse or run the machine while quickly adding all of the liquid. Let it run for a few seconds until the sound changes to a heavy rumbling noise, and then turn it off. Do not overmix; it really takes only a few seconds. Small, even-sized chunks of butter should still be visible in the mass. Using a rubber spatula, scrape the dough into a large, cold bowl.

It's a good idea to prepare two plastic sandwich bags or two sheets of plastic wrap at this time before getting your hands full of dough. Then, using your cool hands, carefully pat the dough together into a large ball, pressing to close any cracks and force out any air. Do not knead or work the dough unnecessarily. Using a knife, cut the ball in half, place each half in the bags or plastic wrap, and form them into disks. Place in the refrigerator for at least 1 hour, or freeze as directed (see page 17).

### STAND MIXER METHOD

Although a stand mixer fitted with the flat paddle attachment has a very different effect on the butter and flour, the method is similar. Rather than cutting the butter, the paddle smears it into flat chunks that get incorporated more slowly into the flour.

Sift the flour into 1-cup and ½-cup dry measuring cups, for a total of 2½ cups (or weigh out 12 ounces/350 g), and place in the mixer bowl. Add the salt and sugar, and let the machine run at medium speed for a few moments to combine. Then lower the speed one notch and begin adding the butter. With the prepared cold egg mixture in hand, watch carefully as the butter gets broken up, and when the chunks are roughly ½ inch (12 mm) long, add half of the liquid. Mix for 15 seconds and then add the remaining half of the liquid. As soon as the dough begins to come together, turn off the mixer, remove

the paddle and bowl, and scrape the dough out onto a floured surface. Press the dough into a ball, cut in half, and place each half in a sandwich bag or in plastic wrap and press into disks. Do not knead or work the dough unnecessarily. Place the tightly wrapped disks in the refrigerator for at least 1 hour or freeze as directed (see page 17).

### MANUAL METHOD

Prepare and store the butter and liquid ingredients in the refrigerator. Sift the flour into 1-cup and ½-cup dry measuring cups, for a total of 2½ cups (or weigh out 12 ounces/350 g), and add to a large bowl. Add the sugar and salt, and mix with a fork or a pastry blender. If the kitchen and ingredients are very

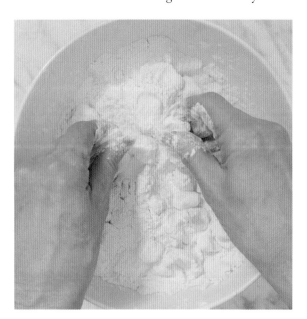

warm, they can now be placed in the refrigerator for 15 to 30 minutes.

Now is a good time to prepare two plastic sandwich bags or two sheets of plastic wrap before getting your hands full of dough. Add the cubed butter to the flour mixture and immediately begin pressing the flour and butter with your fingers or cutting them together using a pastry cutter, a fork, or two knives. Working quickly, continue this process until the lumps of butter are about the size of peas. If the kitchen and/or your hands are very warm, you may need to stop and put the bowl with the ingredients into the refrigerator for 10 to 15 minutes to recool. Then continue until the butter is adequately cut in and the mixture looks like very rough cornmeal. When done, add the ice-cold liquid to the flour and mix together using the pastry cutter or fork. When most of the flour and butter mixture is wet, you can begin pressing the dough together with your hands. Do not knead or work unnecessarily. Once the dough sticks together in a ball, you can cut it into two portions, transfer each to a bag or sheet of plastic wrap, and place in the refrigerator for at least 1 hour, or freeze as directed (see below).

### STORING AND USING THE PREPARED DOUGH

Before use, the dough must rest in the refrigerator for at least 1 hour or up to 12 hours, or be frozen for future use. After 12 hours in the refrigerator, the dough begins to turn gray, so it's best to freeze it if

you don't need it within that period of time. I have kept frozen dough for up to 2 weeks without any noticeable change. When removing the dough from the refrigerator, it's not necessary to allow the dough to warm up before using it if the kitchen is warm. Otherwise, it can be allowed to warm up for 5 to 10 minutes before rolling it out. Frozen dough will need 2 to 3 hours to achieve working consistency, again depending upon ambient temperature.

### PREPARING A PIE SHELL
### WITH BOTTOM CRUST

Roll out 1 batch of pie dough into a round disk about 12 to 13 inches (30 or 33 cm) in diameter and ⅛ (3 mm) thick. Dust the top and bottom with a brush to remove any excess flour. Carefully drape it over the pie plate and gently press it in. Trim any excess dough around the edge of the plate by pressing with your fingers. Add your cooled filling to the pie shell and gently smooth the top so that it's about ¼ inch (6 mm) below the edge of the crust. Place the prepared pie shell with filling in the refrigerator until you're ready to begin adding the top crust and/or decorations.

### COLOR VARIATIONS

One method to add drama and contrast to your pie crust is by using colored dough. While it's possible to simply use food coloring, the results are not always pleasing and can become somewhat gaudy. Naturally colorful foodstuffs such as berries, beets, spinach,

and chocolate provide more subtle and harmonious coloration. Sources for freeze-dried natural coloring agents can be found on the Internet.

To make tinted doughs, the Basic Pie Dough recipe can simply be modified slightly and then a coloring agent added. It's best to leave out the vinegar and egg and simply use 4.5 ounces (135 ml) of mineral water or tap water. Alternatively, fruit juices can be used to intensify the color. A combination of freeze-dried powder and fruit juice will give very intense colors. Since you're leaving out the egg and vinegar, the dough will not be quite as flaky, but it will otherwise have the same consistency. Of course, the color will change upon baking; the darker it is when baked, the browner it will become, like any baked dough. For this reason, the colored dough should not be treated with an egg wash or other browning agent.

Alternatively, if a more variegated coloration is desired, tinting powders can be gently kneaded into the prepared pie dough.

# PURPLE (BLUEBERRY) PIE DOUGH

**MAKES TWO (11-INCH/28-CM) PIE CRUSTS**

2½ cups (350 g) all-purpose flour

½ teaspoon salt

1 teaspoon sugar

3 tablespoons (30 g) freeze-dried blueberry powder

1 cup (2 sticks/200 g) cold, salted butter, cut into small cubes

½ cup (120 ml) ice-cold water

Mix all the dry ingredients together in a bowl. If using a stand mixer, be sure to scrape down the bowl while mixing the dry ingredients a few times so the powder is mixed well, or mix by hand using a wire whisk. Cut in the cold butter until small clumps form. Add half of the water and mix for 1 minute, then add the rest and mix until a ball forms. Refrigerate for 1 hour before using, or freeze in an airtight container or wrapped in plastic wrap. Note that the depth of color will depend upon the amount of powder you use. The more powder added, the deeper and richer the color will be. Thus, the color can vary from a light sky blue to a very deep purple. To obtain an even darker color, you can replace the water with blueberry juice. Freeze-dried powders made from raspberries and blackberries are also available and give pink to reddish variations.

# BROWN (CHOCOLATE) PIE DOUGH

## MAKES ONE (11-INCH/28-CM) PIE CRUST

*This crust is great either as decoration or for a chocolate pie. This recipe is somewhat different from the Basic Pie Dough recipe and yields only half as much, or just enough for one crust. This is usually adequate, as the brown dough is most commonly used for decorative purposes; however, the recipe can be doubled as needed. Cocoa powders vary from darker to lighter, so the resulting dough color will depend upon the color of the powder used.*

1¼ cups (150 g) all-purpose flour

1 cup (100 g) unsweetened cocoa powder

1 teaspoon espresso powder

1 to 3 tablespoons brown sugar (depending upon how bitter your coffee is)

¼ teaspoon salt

½ cup (1 stick/100 g) cold, salted butter, cut into small cubes

6 tablespoons (89 ml) prepared cold espresso or cold coffee (or more as needed)

Mix all the dry ingredients together in a bowl. If using a stand mixer, be sure to scrape down the bowl while mixing the dry ingredients a few times so the powder is mixed well, or mix by hand using a wire whisk. Cut in the cold butter until small clumps form. Add half of the coffee and mix for 1 minute, then add the rest and mix until a ball forms. Refrigerate for 1 hour before using, or freeze in an airtight container or wrapped in plastic wrap.

# RED (BEET) PIE DOUGH

**MAKES TWO (11-INCH/28-CM) PIE CRUSTS**

2½ cups (350 g) all-purpose flour

½ teaspoon salt

1 tablespoon sugar

4 heaping tablespoons (50 g) freeze-dried red beet powder

1 cup (2 sticks/200 g) cold, salted butter, cut into small cubes

⅔ cup (120 ml) ice-cold red beet juice

Mix all the dry ingredients together in a bowl. If using a stand mixer, be sure to scrape down the bowl while mixing the dry ingredients a few times so the powder is mixed well, or mix by hand using a wire whisk. Cut in the cold butter until small clumps form. Add half of the beet juice and mix for 1 minute, then add the rest and mix until a ball forms. Refrigerate for 1 hour before using, or freeze in an airtight container or wrapped in plastic wrap. This crust will have a slight beet flavor, which may not present a problem if the dough is used sparingly as decorative ornaments. Otherwise, it can be used for various savory pies.

# GREEN (SPINACH) PIE DOUGH

**MAKES TWO (11-INCH/28-CM) PIE CRUSTS**

2½ cups (350 g) all-purpose flour

½ teaspoon salt

1 tablespoon sugar

4 heaping tablespoons (50 g) freeze-dried spinach powder

1 cup (2 sticks/200 g) cold, salted butter, cut into small pieces

⅔ cup (120 ml) ice-cold water

Mix all the dry ingredients together in a bowl. If using a stand mixer, be sure to scrape down the bowl while mixing the dry ingredients a few times so the powder is mixed well, or mix by hand using a wire whisk. Cut in the cold butter until small clumps form. Add half of the water and mix for 1 minute, then add the rest and mix until a ball forms. Refrigerate for 1 hour before using, or freeze in an airtight container or wrapped in plastic wrap. This crust will have a slight spinach flavor, which may not present a problem if the dough is used sparingly as decorative ornaments. Otherwise, it can be used for various savory pies.

# COOKIE CRUMB PIE CRUST

MAKES ONE (9-INCH/23-CM) PIE CRUST

*Some fillings such as chocolate and other pudding fillings do not fare well with regular pie crusts. The softness of the filling may not work well with the flakiness of the crust, resulting in a somewhat unpleasant sogginess. Admittedly, this is a matter of taste, but if an alternative is sought, a cookie crumb crust is excellent. Almost any crispy cookie, such as vanilla wafers or chocolate sandwich cookies, can be used. Soft, chewy cookies do not crumb up well. Graham crackers are also a popular choice, and you may even find graham cracker crumbs ready-made. To make your own crumbs, you can either put the cookies in a resealable plastic bag and crush and then roll them with a rolling pin, or you can mix them up in a food processor or blender. Whatever method you use, they should be very fine and homogenous.*

⅔ cup to ¾ cup (1½ to 1¾ sticks/150 to 170 g) salted butter

2 cups (7 ounces/200 g) cookie crumbs

3 tablespoons brown sugar (optional, according to taste and the sweetness of the cookies)

To make the cookie crumbs, you can use either a resealable bag and rolling pin, or a food processor. If using the manual method, place the cookies in the bag, seal the bag, and then begin smashing the bagged cookies with the rolling pin. Once the cookies are broken up into smaller pieces, continue rolling back and forth over the bag until the crumbs are very fine. You don't want any large pieces.

Using a food processor is much easier. Just place the cookies in the work bowl, cover, and chop them up until they are very fine.

Place the crumbs in a large bowl and add the brown sugar, if using. Melt the butter on the stovetop or in the microwave. How much butter you'll need will depend on the type of cookies you're using. Graham cracker crumbs usually require more butter than cookie crumbs. Stir to mix well and then drizzle in the butter while stirring. The crumbs should be saturated with the butter. The mixture will not stick together but should also not be too dry.

Press the cookie crumb mixture into a pie pan and begin spreading out the mixture. Press it down using a flat object, such as a dry measuring cup, to create a smooth, flat surface. Form the edges with your fingers.

Although it is not necessary to prebake a cookie crumb crust, it does make the crust somewhat firmer, improves the texture, and adds a slightly toasted flavor. To prebake, preheat the oven to 350°F (175°C) with the rack in the middle position. Place the prepared crust in the oven and bake for 15 minutes. Remove from the oven and set on a rack to cool until needed.

# BASIC TIPS FOR DECORATING PIE CRUSTS

It's important to follow certain rules when working with pie dough. First and foremost, you must work as carefully and precisely as possible. Edges and corners must be smooth and even, angles must be accurate, and individual pieces must be precisely placed and fitted. Where pieces are joined together, the joint should be smooth and not appear pressed together. If the pie does not look as perfect as possible before baking, it will not look any better when it comes out of the oven. Baking tends to accentuate inaccuracies and mistakes rather than hiding them.

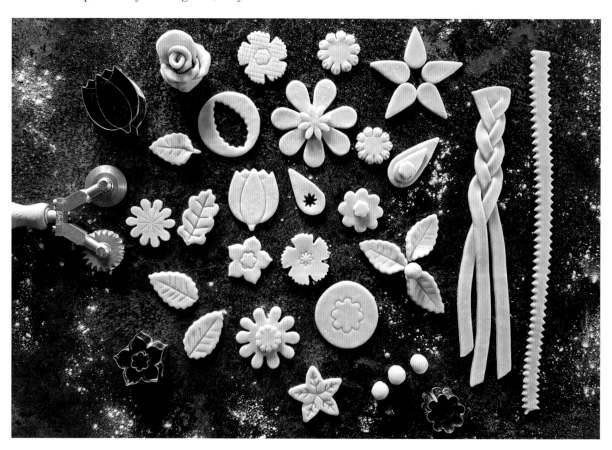

In order to work with the greatest accuracy, the dough must be cool or cold. Warm dough loses its shape and consistency and is nearly impossible to work with. If your work area is very warm, it may be necessary to use a work surface that you can place back in the refrigerator every ten minutes or so. For faster cooling, you can also use the freezer. Flat, borderless pastry lifters or cake lifters work best. Cutting directly on the metal sheets is not a good idea, as it will scratch the sheets and dull the knife blade. Using a cutting mat is advised because the pieces can be slid from the mat onto the metal sheets to be cooled. When cutting with a knife or scalpel, it's important to hold the blade perpendicular to the cutting surface. Cutting at an angle will result in inaccuracy and poorly shaped pieces.

Dusting the work surface with flour and dusting the top of the dough before rolling it out are essential, but be careful not to use excess flour. Too much flour ruins the overall appearance before baking and results in a muddled look when the pie comes out of the oven. Therefore, excess flour should be carefully brushed away using a soft-bristled pastry brush.

By nature, pie dough shrinks as it bakes. Keeping the amount of water in the dough at a minimum helps but cannot completely eliminate shrinkage. Since this is a known variable, it's possible to compensate for it when planning and preparing the crust. It can actually be used as an advantage to increase contrast in your design because of the resulting increased gaps between decorative elements. In addition to shrinking, the dough also puffs up as it bakes. This is not a problem, but keep in mind that it gives additional three-dimensionality and life to the crust.

Using pastry or cookie cutters for pie crust design might not be as simple as it first appears. The cutter should be cold and lightly coated with flour to keep it from sticking to the cool dough. When pressing the cutter into the dough, it's essential to resist the temptation to move the cutter from side to side—like you might when cutting out cookies—as this will deform the piece. It may be necessary to carefully release the cutout piece using a small knife or thin wooden dowel. Once the piece is removed from the cutter, it will be a bit rough around the edges. It's important to hold the piece in one hand and carefully smooth the edges using a finger on your other hand. This smoothing and shaping process will improve the appearance of any piece cut out using a cutter. If the cutter is equipped with an embossing ejector (such as one that presses veins into leaves), it's necessary to first press down firmly while the piece is on the surface in order to emboss the piece deeply. The piece can then be ejected from the cutter. Again, in order for the pieces to look their best and keep their shape, the dough must be kept constantly cool.

At any stage of preparation, the cutout pieces and remaining dough can be placed in the

refrigerator for ten to fifteen minutes until work can again proceed. This is helpful when preparing more complicated designs or when time is limited and you need to work in stages.

If you make a mistake or don't like the look of a cutout part, you can mash the dough back together and roll it out a second time. Try to do this only for small ornaments, as the dough will get tough and lose its flakiness the more it's worked. If a larger part or the whole top cover of your crust gets damaged, it's best to start over and just prepare a new one. Normally, however, there's no reason this should happen. It's also possible to repair tears or rips by pressing pieces of dough onto the broken part and smoothing it with your fingers.

Loose ornamental pieces can be "glued" in place using an egg wash, either made with whole egg or egg white.

Many of my designs do not have vent openings in the top crust. Vent openings are not necessary if the top crust is not crimped or otherwise tightly attached to the bottom crust. Air, steam, or excess filling will simply escape around the edge of the pie. I developed this method a few years ago and have been using it regularly without problem.

## FILLINGS

Since this book is primarily about pie decoration, I don't concentrate on the fillings too much. There are many wonderful books available on the basics of pie making with recipes for fillings. An Internet search will provide titles of many excellent books on the subject. However, I decided to include just a few of my favorite fillings that are well suited to decorating the top crust. These are simply my suggestions, and the recipes can be adapted according to your individual taste. The ingredient amounts will vary depending upon the diameter and depth of the pie pan you are using, so be aware of any adjustments, if needed.

# APPLE PIE FILLING

**MAKES ONE (9 TO 13-INCH/23 TO 33-CM) PIE**

*This simple apple pie is based on a recipe that my husband inherited from his mother. You can make it as sweet or as tart as you like by varying the amount of brown sugar, or you can leave out or add any spices you like. I always prefer tart, firm apples for my pies, and I peel them because I don't generally like the texture of peel in a pie. It's also fun to experiment with a mixture of different types of apples.*

8 to 12 medium-sized apples (tart, firm varieties such as Granny Smith, Pink Pearl, Golden Delicious), peeled and cored

12 tablespoons (180 ml) freshly squeezed lemon juice (optional)

2 tablespoons all-purpose flour

¼ to ¾ cup (50 to 150 g) brown sugar (according to taste and the sweetness of the fruit)

½ to 1 teaspoon ground cinnamon

½ teaspoon freshly ground nutmeg

¼ teaspoon allspice

2 tablespoons butter

Thinly slice the apples into flat slices so the filling can be made smooth under the top crust. Place the apple slices in a large bowl and sprinkle the lemon juice over them if they are very sweet or if you need to keep them awhile before using. The juice will add tartness and also keep the apples from turning brown. Add the flour, brown sugar, cinnamon, nutmeg, and allspice. Mix all the ingredients with your hands or use a large salad spoon and fork. It's important that all of the apple slices be coated evenly with the flour, sugar, and spices.

Pour or spoon the apple mixture into a prepared pie shell and scatter small bits of butter over the surface. Alternatively, you can melt the butter and drizzle it over the top of the apples. Proceed with your top crust, decoration, and baking as directed (see page 32).

For a pleasant variation, add 2 tablespoons (30 ml) of Calvados to the apple mixture before putting it in the crust.

# APPLE AND PASSION FRUIT PIE FILLING

### MAKES ONE (9 TO 13-INCH/23 TO 33-CM) PIE

*I had this once in a restaurant and really liked it, so I re-created the recipe as best I could, and it turned out very nicely. Be sure to use wrinkled, soft passion fruit. The shiny, smooth ones are not ripe!*

4 to 6 large apples (tart, firm varieties such as Granny Smith, Pink Pearl, Golden Delicious), peeled, cored, and coarsely chopped

½ cup (125 ml) passion fruit pulp (strained to remove seeds)

¼ to ½ cup (50 to 100 g) granulated sugar (according to taste and the sweetness of the fruit)

½ cup (125 ml) and 1 tablespoon (15 ml) water, divided

3 to 4 teaspoons cornstarch

2 tablespoons butter

Place the apples, passion fruit pulp, sugar, and ½ cup (125 ml) of water in a large saucepan over low heat and simmer for 5 to 10 minutes, until the apples begin to soften. Mix the cornstarch with 1 tablespoon (15 ml) of water in a small bowl and then add to the apple mixture. Continue to let the mixture simmer over low heat, stirring continuously, until it's thickened. Set aside to cool.

Pour or spoon the apple and passion fruit mixture into a prepared pie shell and scatter small bits of butter over the surface. Alternatively, you can melt the butter and drizzle it over the top of the fruit. Proceed with your top crust, decoration, and baking as directed (see page 32).

# CHERRY PIE FILLING

**MAKES ONE (9 TO 13-INCH/23 TO 33-CM) PIE**

*This is a very simple filling and an all-time favorite. Served with vanilla ice cream or whipped cream, it is always a delight.*

3¼ to 5 cups (30 to 38 ounces/850 to 1050 g) sour cherries, fresh, frozen, or canned and drained

⅓ to ½ cup (40 to 60 g) cornstarch, or ⅔ to 1 cup (80 to 125 g) tapioca starch

1 to 2 cups (200 to 400 g) granulated sugar (according to taste and the sweetness of the fruit)

Place the cherries, cornstarch or tapioca starch, and sugar in a large saucepan. Depending upon the amount of juice from the cherries, you may need to add 1 to 2 tablespoons (15 to 30 ml) of water. Stir to mix and cook over medium heat, stirring constantly, until the mixture thickens. Once it is thick, turn off the heat and place the pan in cold water in the sink to cool down. When cool, spoon the cherry mixture into a prepared pie shell and proceed with your top crust, decoration, and baking as directed (see page 32).

For a quick variation, you can add a handful of chocolate chips, or simply break up good-quality chocolate into little chunks and add them to the warm filling.

# CRANBERRY–ORANGE PIE FILLING

**MAKES ONE (9 TO 13-INCH/23 TO 33-CM) PIE**

*My mother-in-law used to make a marvelous cranberry–orange sauce that we still always make for Thanksgiving. I decided to try making a pie out of the same mixture and found a number of recipes for pies like this on the Internet. After some experimentation, I combined a few different ideas from various recipes to come up with this one. If you use less sugar, you'll have a very tart pie, indeed! I sometimes even add a little more, but it's a matter of taste.*

4 to 6 cups (400 to 600 g) fresh or frozen cranberries, divided

⅓ to ½ cup (85 to 120 ml) freshly squeezed orange juice

2 teaspoons finely grated orange zest

¾ to 1 cup (170 to 200 g) granulated sugar

2 tablespoons all-purpose flour

2 to 3 tablespoons cornstarch, or 4 to 6 tablespoons tapioca starch

½ to 1 teaspoon ground cinnamon

1 to 2 tablespoons butter

Clean the cranberries and check for spoiled ones if necessary. Coarsely chop 2 cups (200 g) of the cranberries in a blender or by hand. Leave the remaining 2 cups (200 g) whole. Combine the chopped and whole cranberries in a large bowl and add the orange juice and zest. Sprinkle the sugar, flour, cornstarch, and cinnamon over the berries and stir well. Make sure the berries are well coated with the dry ingredients.

Pour or spoon the cranberry–orange mixture into a prepared pie shell and scatter small bits of butter over the surface. Alternatively, you can melt the butter and drizzle it over the top of the fruit. Proceed with your top crust, decoration, and baking as directed (see page 32).

# CREAMY DARK CHOCOLATE PIE FILLING

## MAKES ONE (9 TO 10-INCH/23 TO 25-CM) PIE

*Although this recipe is somewhat more time-consuming than the simple "pudding-pie" recipes, it's worth the effort. The chocolate filling has much more substantial body and taste than the soft filling of a simpler pudding pie.*

⅔ cup (150 g) butter, cut into cubes

7 ounces (200 g) best-quality dark chocolate, chopped or broken up

3 medium or large eggs

¼ cup (50 g) granulated sugar

½ cup (120 ml) heavy cream

Preheat the oven to 350°F (175°C) with the rack in the middle position.

Place the butter and chocolate in the top of a double boiler. If you don't have a double boiler, you can easily make one by placing a medium-size pot with a few cups of water on the stove over low heat. Over the pot, place a heatproof bowl that is just large enough to not slip inside the pot but that fits snugly so as not to let the steam escape. The bottom of the bowl should be a few inches above the boiling water. Slowly melt the chocolate and butter until it is smooth and silky. Stir to blend completely, then remove the mixture from the heat to cool at room temperature.

In a second larger bowl, beat the eggs together with the sugar. When the chocolate mixture is cooled, add it to the egg–sugar mixture one spoonful at a time, stirring gently. Once all of the chocolate is added, pour in the cream in a stream while stirring constantly to create a smooth, creamy mixture. Transfer immediately to a prepared cookie crumb crust and spread evenly. Bake for 15 minutes, then remove from the oven to let cool on a cooling rack.

# BAKING TECHNIQUES

As attractive, intricate, and beautiful as a freshly decorated pie might be, it is not complete until it's baked. Although pie decoration does not require any special baking techniques, it is useful to review some ideas about pie baking in general. If you are a seasoned pie baker and have your own tried-and-true method for baking, be sure to use it on a decorated pie just as you would otherwise. You'll quickly learn whether you need to make any changes to optimize the results. Here is the baking method I have found to work well in my own kitchen.

The requirements for baking a two-crust pie are relatively simple. The upper crust must take on a lovely golden-brown color, the filling must be cooked, and the bottom crust must be properly baked. There are three primary variables: temperature, time, and placement in the oven. These are also interdependent, so if you change one, you'll likely need to adapt one or both of the other two. If you simply place a pie in the middle of an oven with moderate temperature and leave it there for one hour, it may get satisfactorily done. However, there is an equally good chance that the top crust may be too light or too dark and the bottom crust may remain underbaked or raw. Since we are focusing on pie aesthetics here, we want to optimize the baking technique to provide the most attractive and delicious results.

I covered the various types of ovens available to the home baker in the section on useful tools (see page 3). In the following, I will make recommendations on baking in a standard electric oven with top and bottom heat since I have the most experience using this method and I believe it's the most common for home bakers. If you use a gas or convection oven, you may need to experiment a bit to find the best baking variables for your pies.

## BAKING A TWO-CRUST FRUIT PIE

Begin by checking that your oven is clean and that the drip pan is protected by clean aluminum foil. If you don't use foil, you'll wish you had when it comes time to clean the oven. Also, if the foil is not clean to start with, your kitchen will soon be filled with smoke. The oven should never be used without a drip pan in the bottommost position. This is important for proper distribution of heat in the oven and for preventing the bottom of the oven from getting covered with drips that can burn into the enamel because of the intense heat of the metal. If the oven has a window, make sure it's clean and provides a good view of your pie.

Next, move the rack to the lower third of the oven, not the bottom position. The reason for baking in the lower third of the oven is to avoid burning the upper crust while the lower crust and filling get baked. The closer the pie is to the bottom of

the oven, the more heat that's available to the bottom of the pie. If for whatever reason you are having trouble getting the top crust to brown, you can move the pie up to the middle of the oven, but this is usually not necessary.

Preheat the oven using top and bottom heat to 400°F (200°C). The oven should always be preheated to the correct temperature before baking. You may have a control light or signal that will turn off or beep when the oven reaches the correct temperature. Alternatively, you can also place a thermometer inside the oven to monitor the correct temperature.

To maintain the crust's shape and reduce shrinkage, be sure the pie is cold when it goes into the oven. After completing all decoration, the pie should go into the refrigerator for at least 30 minutes, or preferably 1 hour. Thirty minutes in the freezer can be even better. A completely frozen pie can be baked, too; however, there can be issues.

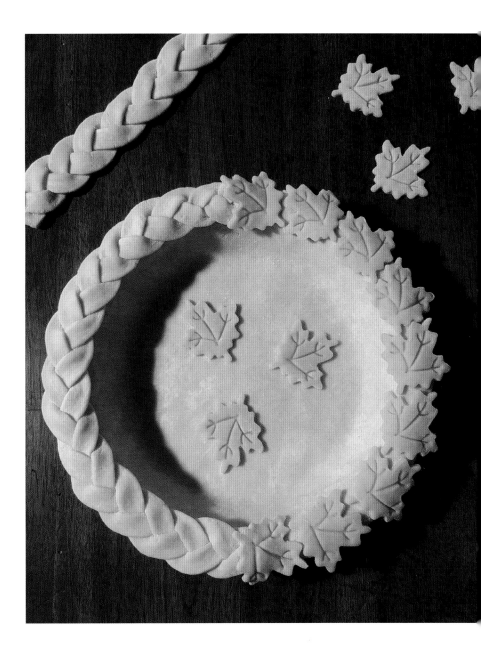

The filling and bottom crust will take longer to be adequately baked. Even when using aluminum foil to protect the top crust, it still may get burned. Applying an egg wash before baking helps, but the results can often be somewhat disappointing because discoloration and changes to the surface structure can also occur.

Once the pie is set on the bottom rack in the preheated oven, set your timer for 20 minutes. It's important to keep an eye on the pie in the oven for those first 15 to 20 minutes to make sure the decorations remain in place and the pie is baking evenly. After 20 minutes, turn the oven temperature down to 350°F (175°C) and set the timer for another 45 minutes. After about 30 minutes, it's a good idea to check the browning of the top crust. If it begins to brown too quickly or is getting too dark, simply place a sheet of aluminum foil loosely over the top of the pie. Occasionally, the outer edge of the pie will begin to brown more quickly than the inner areas, and in that case you can use a commercial pie ring made of metal or silicone, or simply cut a ring out of foil and place it around the edge of the pie. This is also helpful if small decorations begin to brown too quickly. Simply cut or tear bits of foil and lay them over the affected parts of your pie.

The pie is done baking when the top crust is golden brown and the filling bubbles throughout. Remove the pie from the oven and place on a cooling rack to cool before cutting and serving.

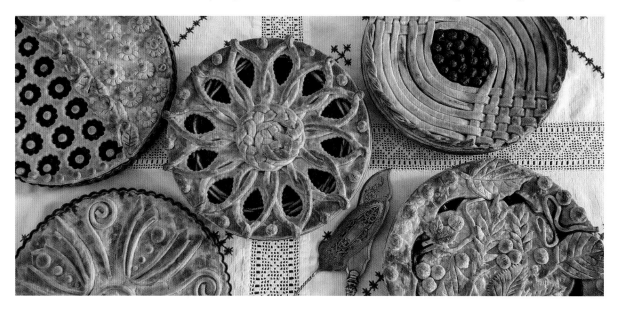

# Beginner Projects

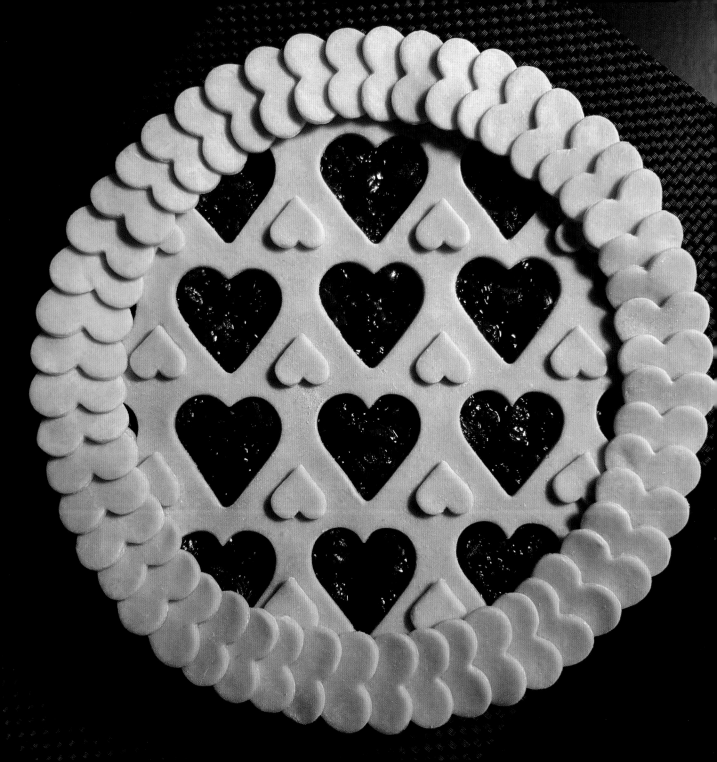

# HEARTS, HEARTS, HEARTS

## MAKES ONE (11-INCH/28-CM) PIE

*This is an excellent beginning project to try your hand at pie decorating. It's really quite easy to make, and everyone loves hearts. Any pie filling can be used that isn't too lumpy and can be smoothed out on the surface. It is an excellent choice for Valentine's Day or a special birthday celebration.*

1 prepared pie shell with bottom crust and filling of your choice (page 26)

**TOP CRUST**
2 recipes Basic Pie Dough (page 14)

**SPECIAL EQUIPMENT**
Ruler
2-inch (5-cm) heart-shaped cookie cutter
1-inch (2.5-cm) heart-shaped cookie cutter
Scissors
Small sharp knife
1½-inch (4-cm) heart-shaped cookie cutter
Small artist's paintbrush

**EGG WASH**
1 egg, beaten with a few drops of water

Keep your prepared pie shell with filling in the refrigerator. Roll out both batches of dough into round disks about 12 inches (30 cm) in diameter and ⅛ inch (3 mm) thick. Dust each crust with a brush to remove any excess flour. Transfer the disks to a lightly floured pastry lifter and place them in the refrigerator to chill for 15 minutes. Remove one disk from the refrigerator and proceed as directed. When you've used up all the dough from the first disk, remove the second one from the refrigerator and continue with the next steps.

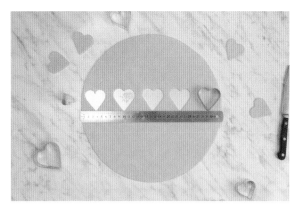

**1.** Place the ruler just above the center line and begin cutting out the hearts using the largest (2-inch/5-cm) cutter. Use the ruler to make sure that the distance between the hearts remains equal (about 1 inch/2.5 cm).

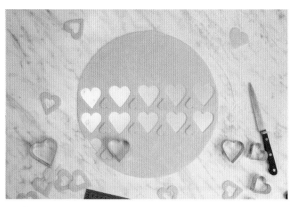

**2.** Continue cutting additional rows of hearts, working downward to complete the main layer. Measure the distance between the horizontal rows to keep them equal.

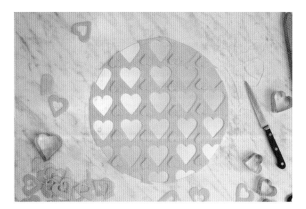

**3.** From the hearts cut out of the top crust, you can cut out the small hearts with the smallest (1-inch/2.5-cm) cutter and carefully arrange them upside down in between the rows of cutout hearts. This will give you practice placing the small hearts and positioning them accurately.

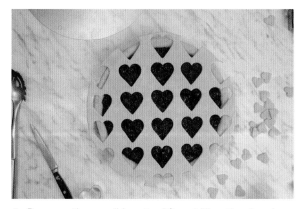

**4.** Remove the small hearts. After chilling the dough on the pastry lifter, transfer it to the top of the prepared pie, making certain the pattern is centered.

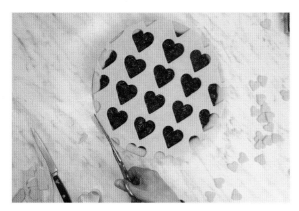

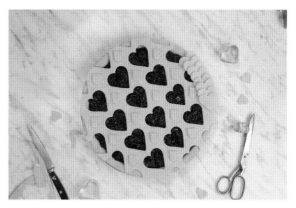

**5.** Carefully trim the edge using scissors and replace the small hearts back on top of the crust as before. Use the knife, if needed, to carefully move them without damaging them.

**6.** Using the middle-sized (1½-inch/4-cm) cookie cutter, cut out enough hearts to cover the entire outer edge of the pie. Place them in an overlapping pattern as shown. Continue until the circle is complete and even.

Place the prepared pie in the refrigerator for 30 minutes before baking. Preheat the oven to 400°F (200°C) with the rack in the bottom position.

Before baking, return the pie to the work surface. Using the small paintbrush, carefully apply the egg wash onto the top crust and decorations only. Place the pie in the oven and bake as directed (see page 32). If the decorations begin to brown excessively, loosely cover the pie with a sheet of aluminum foil or a pie shield. Remove from the oven and let cool on a cooling rack.

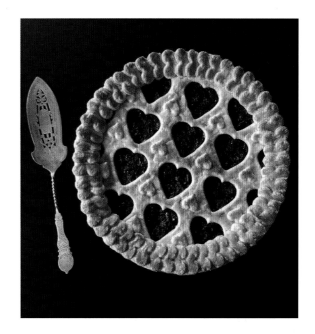

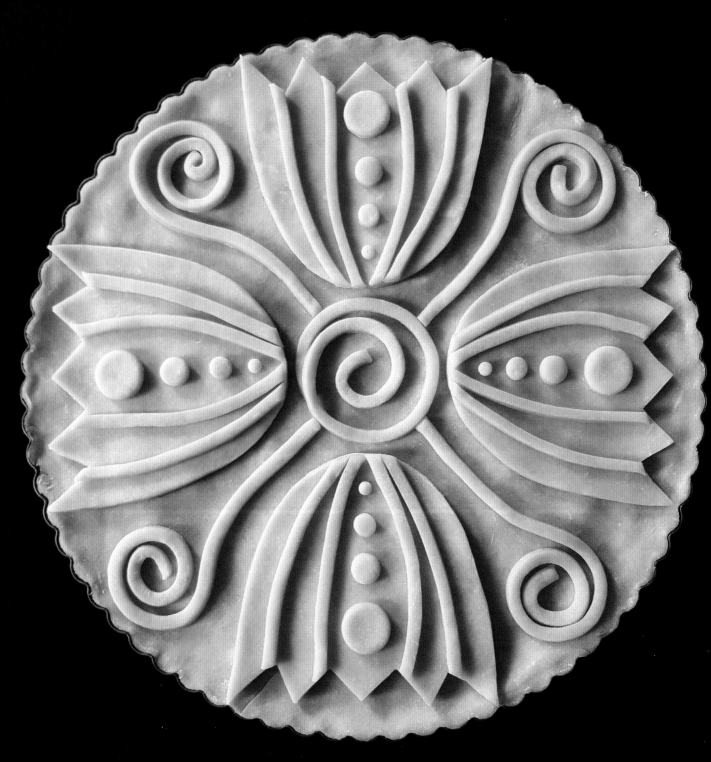

# THE FIRST TULIPS OF SPRING

**MAKES ONE (13-INCH/33-CM) PIE**

*We don't have harsh winters where I live, but they are still damp, cold, and long, sometimes lasting into March. It's always a joy to see the first snowdrops and crocuses appear and then the amazing yellow daffodils. However, it really feels like spring when the tulips bloom in all of their splendor. This design isn't difficult to make but will certainly impress your guests, especially if you serve it in the spring on a table next to a vase full of tulips.*

1 prepared pie shell with bottom crust and filling of your choice (page 26) in a 13-inch (33-cm) tart pan with fluted edge and no lip

**TOP CRUST**

3 recipes Basic Pie Dough (page 14)

**SPECIAL EQUIPMENT**

4 copies of the tulip template including the spiral template (page 154)

Scissors

Scalpel or craft knife

Ruler

1-inch (2.5-cm) circle cookie cutter

½-inch (1.25-cm) circle cookie cutter

¼-inch (6-mm) circle cookie cutter

Small artist's paintbrush

**EGG WASH**

1 egg, beaten with a few drops of water

Photocopy the tulip template so at the widest point it has a width of about 4 inches (10 cm). Then cut it out using a pair of scissors.

Keep your prepared pie shell with filling in the refrigerator. Roll out the three batches of dough into disks about 13 inches (33 cm) in diameter and ⅛ inch (3 mm) thick. Dust with a brush to remove any excess flour. Transfer two of the disks to lightly floured pastry lifters, cover with plastic wrap, and place them in the refrigerator to chill. Place the third disk on the prepared pie shell. Remove any excess around the edges by pressing with your fingers. Remove a second rolled-out disk from the refrigerator and place on top of a cutting mat. Proceed as directed.

**1.** Carefully cut out the tulips by tracing around the edges of the template. You will be using the same template, but it doesn't hurt to have a few extra printouts in case you cut into the first one.

**2.** Carefully smooth the edges of the tulips after cutting them out. Then place them on the top crust on the prepared pie shell with filling. Arrange them as shown on page 40.

**3.** Place the third rolled-out disk on your cutting mat or work surface. Cut out thin strips about ¼ inch (6 mm) wide using the ruler. Using your fingertips, begin winding the strips into spirals using the spiral template on page 154 as a guide. Place the first spiral in the center of the pie.

**4.** Wind another spiral until you have three turns, leaving the long end free as demonstrated. You will need four of these long-tailed spirals.

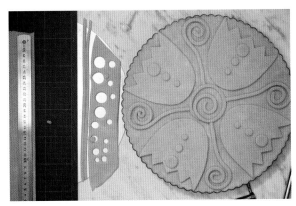

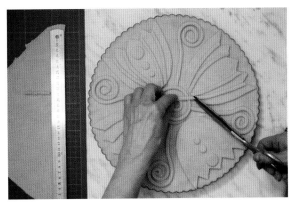

**5.** Arrange the long-tailed spirals as shown. Cut out three or four small circles with each of the different cookie cutters and smooth them with your fingers. Place them on top of the tulips as shown or create your own unique pattern.

**6.** Cut lengths of the remaining strips to create the edges of the tulip petals. Once they are in place, trim them to the appropriate length with scissors.

When finished, the pie should look like page 40.

Place the prepared pie in the refrigerator for at least 30 minutes. Preheat the oven to 400°F (200°C) with the rack in the bottom position.

Before baking, return the pie to the work surface. Using the small paintbrush, carefully apply the egg wash. Place the pie in the oven and bake as directed (see page 32). If the decorations begin to brown excessively, loosely cover the pie with a sheet of aluminum foil or a pie shield. Remove from the oven and let cool on a cooling rack.

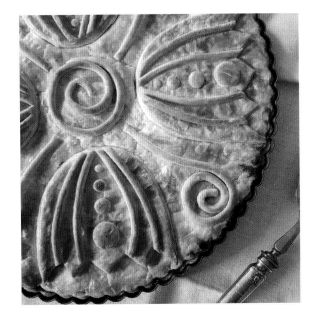

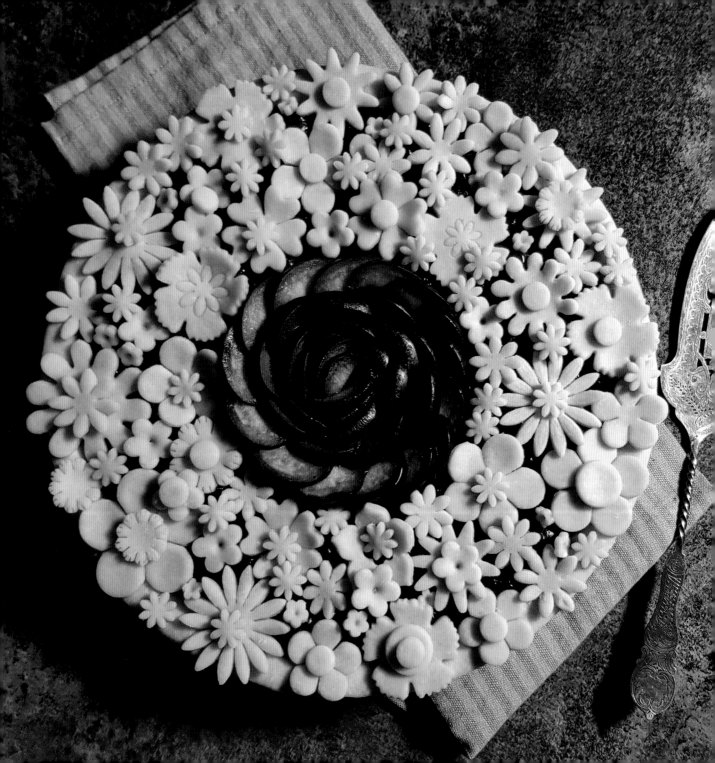

# SUMMER FLOWER GARDEN: PLUMS AND CHERRIES IN FULL BLOOM

**MAKES ONE (9 TO 13-INCH/23 TO 33-CM) PIE**

*This is a very simple design that can be assembled quickly and is a real eye-catcher when served. The only prerequisite is a collection of inexpensive metal and/or plastic cutters, as shown in the photos.*

1 prepared pie shell with bottom crust of your choice and cherry filling (page 29)

6 red plums or as many as needed for the size of the pie

**TOP CRUST**
1 recipe Basic Pie Dough (page 14)

**SPECIAL EQUIPMENT**
Flower-shaped cookie cutters ranging in size from ½ inch (12 mm) to about 1½ inches (4 cm), as shown in photo

1-inch (2.5-cm) circle cookie cutter

½-inch (1.25-cm) circle cookie cutter

Small artist's paintbrush

**EGG WASH**
1 egg, beaten with a few drops of water

Keep your prepared pie shell with filling in the refrigerator. Transfer the prepared pie shell to the work area. Cut the plums into halves, remove the stones, and cut the fruit into ¼-inch (6-mm) slices. Place the slices in concentric circles, forming a flowerlike shape in the middle of the pie. The circle of plums should have a diameter of about 5 inches (12 cm). Place back in the refrigerator until ready to decorate.

Roll out the dough for the decorations into a disk about 13 inches (33 cm) in diameter and ⅛ inch (3 mm) thick. Dust with a brush to remove any excess flour. Transfer to a lightly floured pastry lifter and chill for 15 minutes in the refrigerator.

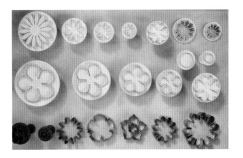

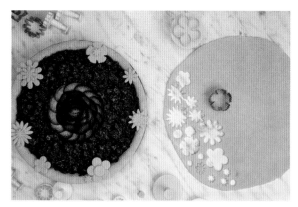

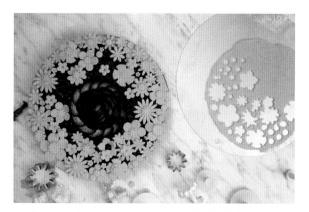

**1.** Cut out the flowers and begin arranging from the outer edge.

**2.** Continue inward until the center fruit circle is reached.

Begin cutting out various flowers using the different cutters. Carefully smooth the edges with your fingers and place them on the periphery of the prepared filling as shown in step 1.

When finished, check the arrangement and then chill the pie in the refrigerator for 30 minutes. Preheat the oven to 400°F (200°C) with the rack in the bottom position.

Before baking, return the pie to the work surface. Using the small paintbrush, carefully apply the egg wash. Place the pie in the oven and bake as directed (see page 32). If the decorations begin to brown excessively, loosely cover the pie with a sheet of aluminum foil or a pie shield. Remove from the oven and let cool on a cooling rack.

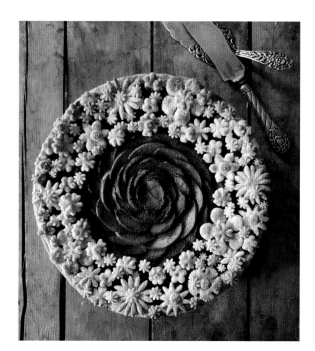

# DOING THE TWIST

*When is a braid not a braid? When it has only two strands, of course. However, because each track of this twist design is made up of three strips, it looks as if it's braided. Although it looks quite impressive, it's actually quite simple to make. I make a blueberry pie with this top crust and decorate the finished pie with a handful of fresh blueberries. You can do the same with other berries or make another fruit filling and skip the fruit decorations.*

*The design uses five "pseudo braids" that are actually just two twisted strands with three strips of dough per strand. This combination gives the illusion of a complex braid structure, and yet it's very simple. It's necessary to work quickly once the strips of dough are cut. They must be warm enough to be flexible, but we don't want them to stay warm too long or the butter will begin to melt and blend in with the flour, leaving the crust less flaky and tender. This won't happen if you work quickly enough.*

1 prepared pie shell with bottom crust and filling of your choice (page 26)

TOP CRUST

2 to 3 recipes Basic Pie Dough (page 14), according to the size of the pie

SPECIAL EQUIPMENT

Rolling cutter

Ruler

Small artist's paintbrush

EGG WASH

1 egg, beaten with a few drops of water

Keep your prepared pie shell with filling in the refrigerator. Roll out both batches of dough into disks about 13 inches (33 cm) in diameter and ⅛ inch (3 mm) thick. Place the rolled-out dough on your work surface and then, using the ruler and rolling cutter, cut out a total of 30 strips, each ½ inch (1.25 cm) wide. Transfer half of the strips on a pastry lifter to the refrigerator to chill. Proceed as directed.

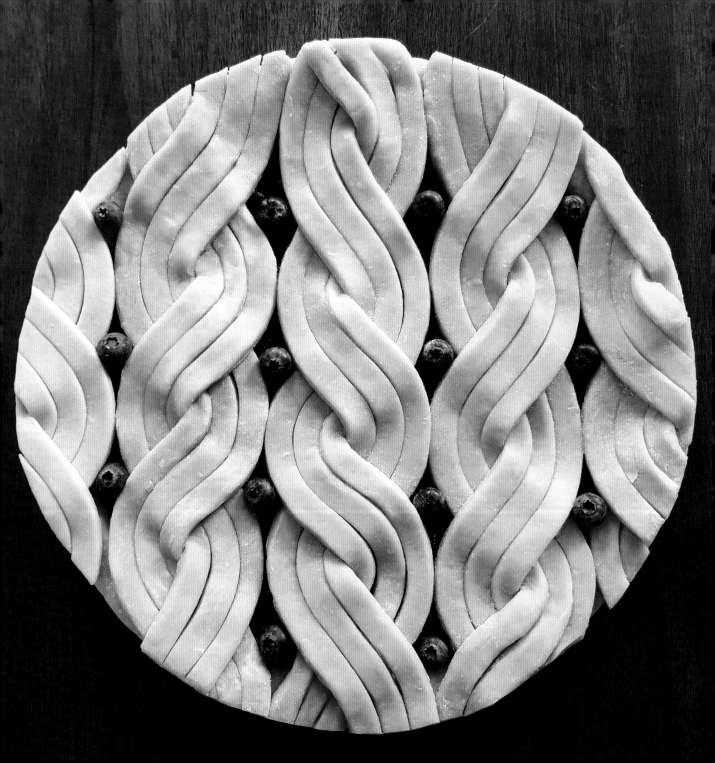

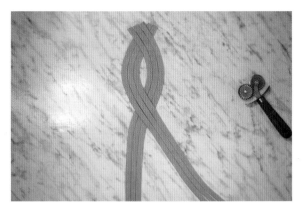

**1.** Lay out two tracks consisting of three strips of dough each. Lay the left-hand track over the middle of the right-hand track and then bring the top of the right-hand track over the top of the left-hand track as shown.

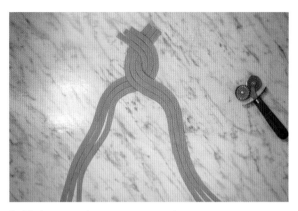

**2.** Tighten up the crossover as shown.

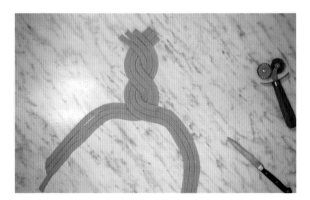

**3.** Repeat the crossover, keeping the strands tightly aligned.

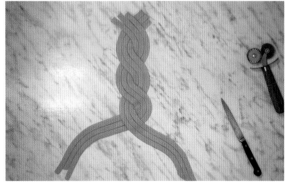

**4.** Repeat again so you have three crossovers.

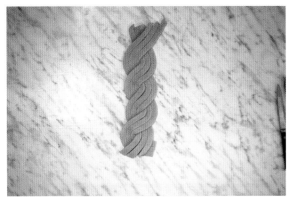

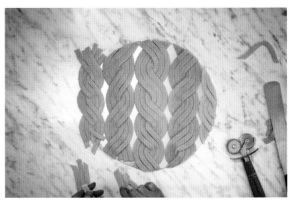

**5.** Repeat once more and then trim off the ends. The pseudo braid that is placed in the middle of the pie will be the longest of the five.

**6.** Make four more twists, trimming the outer edges to fit the diameter of your pie pan. You will need to cut strips out of the middle of the second disk of pie dough so they are long enough for the other central twists. You may need to press the twists lightly together so they fit well.

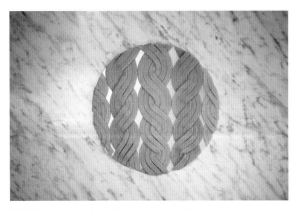

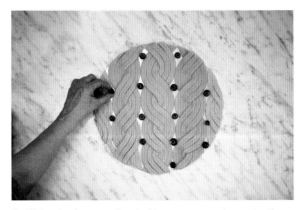

**7.** When the twists fit together and have the correct outer diameter, you can begin placing them on top of the pie filling.

**8.** Either before or after baking, you can decorate the crust by adding the appropriate berries between the twists, if you like.

Before baking, return the pie to the work surface. Using the small paintbrush, carefully apply the egg wash. Place the pie in the oven and bake as directed (see page 32). If the decorations begin to brown excessively, loosely cover the pie with a sheet of aluminum foil or a pie shield. Remove from the oven and let cool on a cooling rack.

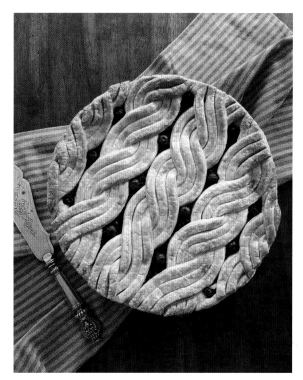

For the sake of clarity, the photo in step 8 shows the completion of the top crust before placing it on top of the filling. The picture above shows the finished crust on top of the actual pie filling, ready to go in the oven.

Place the pie in the refrigerator for at least 30 minutes. Preheat the oven to 400°F (200°C) with the rack in the bottom position.

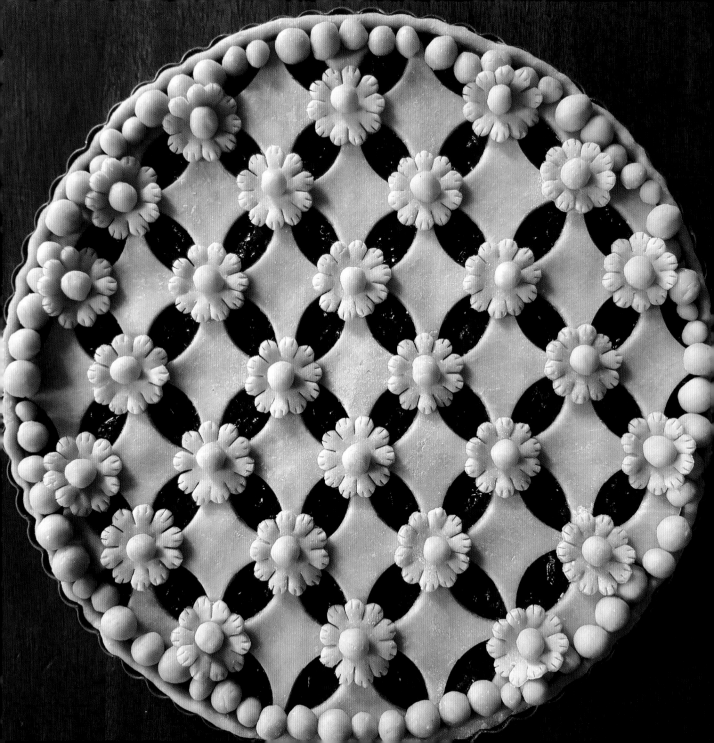

# A FIELD OF CARNATIONS

MAKES ONE (11 TO 13-INCH/28 TO 33-CM) PIE

*In many countries, the carnation is a symbol of emotionality, affection, or love, and the flowers themselves are among the earliest to have been cultivated. Everyone recognizes a carnation, and they bring joy and a feeling of warmth. Since I use this crust on berry and cherry pies, I thought it would be appropriate to add different-sized spheres of dough representing the delicious spheres of fruit that are hiding beneath the crust.*

*This design is deceptively easy to make and looks elegant when baked. Making the little balls of dough takes the most time, but I always enjoy the task. I associate it with my memories of childhood and playing with modeling clay. Please read through the instructions first to understand the correct order of steps. Removing and replacing the small spheres is rather tedious but necessary so that you know how many spheres you will need before you attach them with egg wash.*

1 prepared pie shell with bottom crust and cherry filling (page 29) or filling of your choice (page 26) in a tart pan with fluted edge and no lip

**TOP CRUST**

2 recipes Basic Pie Dough (page 14)

**SPECIAL EQUIPMENT**

¾ by 1½-inch (2 by 4-cm) oval cookie cutter with pointed ends

Ruler

Scalpel or craft knife

Small artist's paintbrush

**EGG WASH**

1 egg, beaten with a few drops of water

Keep your prepared pie shell with filling in the refrigerator. Roll out both batches of dough into disks about 13 inches (33 cm) in diameter and about ⅛ inch (3 mm) thick. Dust with a brush to remove any excess flour. Transfer one disk to a lightly floured pastry lifter and place in the refrigerator to chill. Trim the second disk to fit your pie shell and place on your work surface. Proceed as directed.

**1.** Begin by finding the horizontal center line and cut out ovals with the cutter along the ruler on the line, each at 45° and 135° angles. Then move up or down to make the next row of ovals, as shown in this picture.

**2.** Using the back of a paring knife, smooth out any rough areas of the cutouts. Place the finished disk in the freezer for 30 minutes to firm it up. While the disk is freezing, you can begin to prepare the decorations.

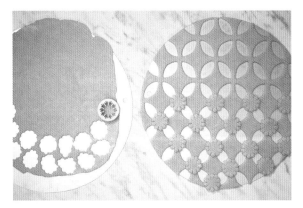

**3.** Cut out carnations from the second disk of dough using the cookie cutter and apply them to the corners between the oval cutouts as shown.

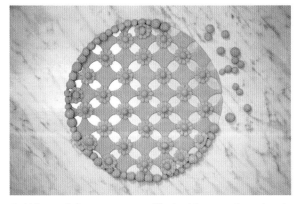

**4.** When all the spaces are filled with carnations, begin rolling different-sized pieces of dough in your hand to form small spheres. Lightly press to flatten one side so the spheres will stay in place and will not roll. Place them on the flowers and around the edge as shown.

Please note that, for the sake of clarity, I have shown the work here on a pastry lifter. If you do this, you'll need to take your work completely apart in order to place the top crust on top of the filling. To save yourself this extra work, you should transfer the stiff top crust with oval openings to the top of your pie before you continue to the next step. Then remove the second rolled-out disk of dough from the refrigerator and place it on your work surface. You can then move on to the next steps.

When finished, carefully transfer the complete pie to the refrigerator for at least 1 hour, or freeze up to 1 week before baking.

Preheat the oven to 400°F (200°C) with the rack in the bottom position.

Before baking, return the pie to the work surface. Remove the spheres and use the small paintbrush to apply egg wash to the top crust and the carnations, and then replace the spheres with the flat side down. The egg wash will help the spheres stay in place during baking. Place the pie in the oven and bake as directed (see page 32). If the decorations begin to brown excessively, loosely cover the pie with a sheet of aluminum foil or a pie shield. Remove from the oven and let cool on a cooling rack.

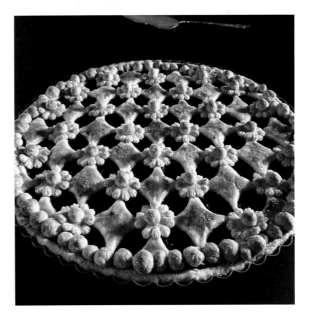

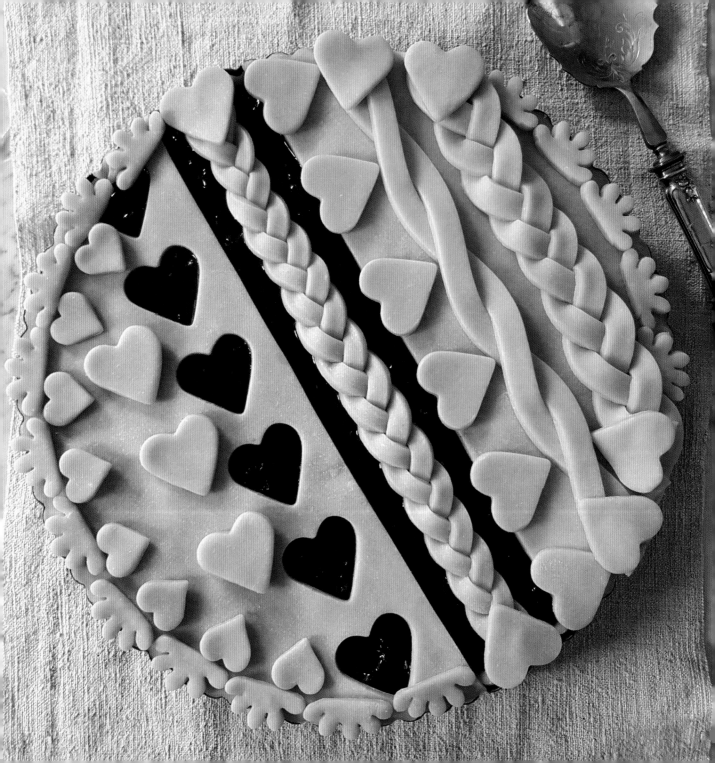

# BRAIDS AND HEARTS

~~~~~~~~~~~~~~~~~~~~~~~~~~~~~~~~~~~~~~~~~~~~~~~~~

**MAKES ONE (10 TO 11-INCH/25 TO 28-CM) PIE**

*This design offers a number of options and is attractive enough to make your guests' eyes pop. It gives you the opportunity to practice techniques such as braiding and twisting using cookie cutters and customizing cutouts. The results will clearly demonstrate your proficiency in these techniques, in spite of the fact that it's really not that difficult. All in all, it's a winner.*

1 prepared pie shell with bottom crust and filling of your choice (page 26) in a tart pan with fluted edge and no lip

**TOP CRUST**

2 recipes Basic Pie Dough (page 14)

**SPECIAL EQUIPMENT**

Ruler

Rolling cutter

1½-inch (4-cm) heart-shaped cookie cutter

1½-inch (4-cm) scalloped-edged circle cookie cutter

¾-inch (2-cm) heart-shaped cookie cutter

Small artist's paintbrush

**EGG WASH**

1 egg, beaten with a few drops of water

Roll out both batches of dough into disks about 13 inches (33 cm) in diameter and ⅛ inch (3 mm) thick. Dust with a brush to remove any excess flour. Transfer one disk to a lightly floured pastry lifter and place in the refrigerator to chill until needed. Place the other disk on your work surface and proceed as directed.

**1.** Using the ruler and rolling cutter, cut out eight ½-inch-wide (12-mm-wide) strips.

**2.** Use three of the strips to make a braid that is as long as the diameter of your pie pan.

**3.** Transfer the second dough disk to your work area and cut it in two parts, one part slightly larger than the other.

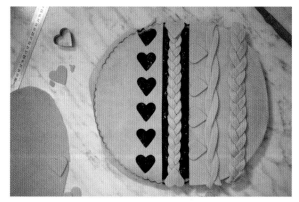

**4.** Cut out the hearts with the large (1½-inch/4-cm) heart cutter as shown. Carefully place the two sheets of dough on the prepared pie shell with filling and press off any excess if using a pan with a scalloped edge. Cut smoothly around the edges if using a pan with a flat edge. Prepare a twist using two of the strips prepared in step 1. Add the braids, twists, and hearts as shown.

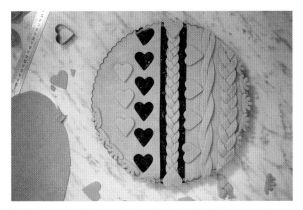

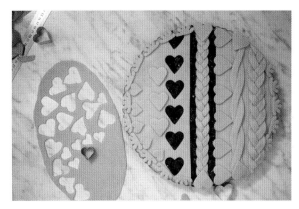

**5.** Cut out scallops and cut them in half to create the edge decorations. The twist and second braid are suggestions for decorating the crust, but you can use your own imagination for placement.

**6.** Cut out small hearts with the small (3/4-inch/2-cm) heart cutter from the remaining dough and finish the decoration.

When finished, the pie should look like page 56.

Place the pie in the refrigerator for at least 30 minutes to chill. Preheat the oven to 400°F (200°C) with the rack in the bottom position.

Before baking, return the pie to the work surface. Carefully apply the egg wash using the small paintbrush. It's a good idea to adhere the scalloped-edge decorations in place with egg wash to keep them from falling off. Place the pie in the oven and bake as directed (see page 32). If the decorations begin to brown excessively, loosely cover the pie with a sheet of aluminum foil or a pie shield. Remove from the oven and let cool on a cooling rack.

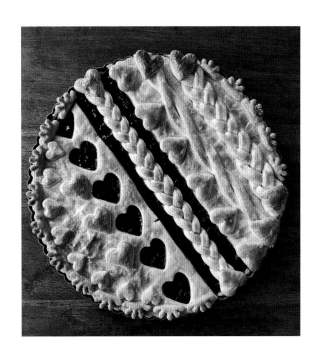

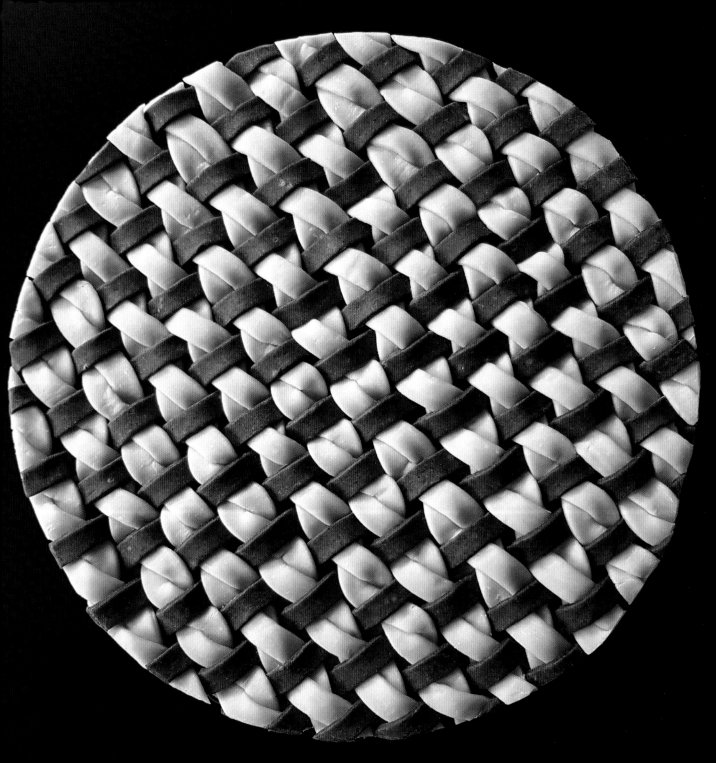

# THE BICOLOR LATTICE

*Simple lattice crusts are very attractive and quite easy to make. One way to make them even more dramatic is to alternate the colors of dough. Another way is to add dimension to the crust by twisting alternating rows. This design combines both of these methods to make a very appealing and attractive top crust for any fruit or berry pie. It does require accuracy in cutting and assembly, but it is otherwise not difficult. Since it will take some time to assemble, it will be necessary to rechill the dough in between steps. If you prefer the lighter parts of the crust to brown more, you can carefully apply egg wash with a small artist's paintbrush. If you don't use egg wash, the baked pie crust will be a bit paler, but the contrast with the colored dough will be greater. I used egg wash on the pie shown on page 64.*

1 prepared pie shell with bottom crust and filling of your choice (page 26)

### TOP CRUST

2 recipes Basic Pie Dough (page 14)

1 recipe Purple (Blueberry) Pie Dough (page 18) or color of choice

### SPECIAL EQUIPMENT

Rolling cutter

Ruler

Small artist's paintbrush

### EGG WASH (OPTIONAL)

1 egg, beaten with a few drops of water

Keep your prepared pie shell with filling in the refrigerator. Roll out all three batches of dough into disks about 13 inches (33 cm) in diameter and ⅛ inch (3 mm) thick. Dust disk with a brush to remove any excess flour. Transfer one white disk to a lightly floured pastry lifter and chill in the refrigerator until needed. Place the other white disk and the purple disk on your work surface and proceed as directed.

**1.** Cut the basic pie dough disk into ½-inch (12-mm) strips. Lay two strips next to each other and carefully wind them around each other as shown.

**2.** Cut the purple dough disk into ½-inch (12-mm) strips the same way, but do not twist them.

**3.** Lay the white twists next to one another, with the longest in the middle. Turn up every other one on itself in the middle and lay a single strip of purple dough perpendicular to the white strips, as shown.

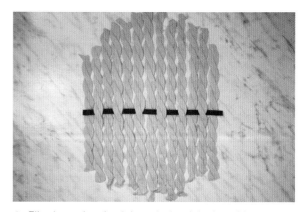

**4.** Flip the twists back into their original positions across the purple strip.

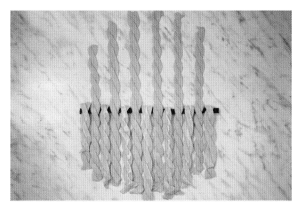

**5.** Now turn down the other twists—the ones you did not fold back the first time—toward the middle as shown.

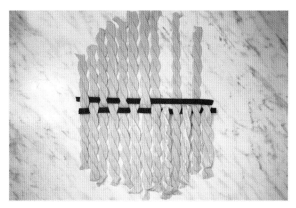

**6.** Place a second purple strip parallel to the first and above it and flip the twists back up into their original position.

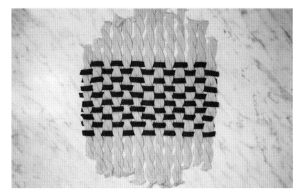

**7.** Repeat these alternating steps by moving up one time and down the next until complete.

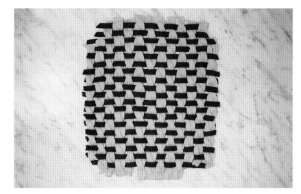

**8.** When complete, carefully straighten the lines in both directions, making certain not to stretch the strips. Place the complete top crust in the freezer for at least 30 minutes until frozen and firm so it doesn't become distorted. If it's not yet firm, wait an additional 15 minutes.

Remove the top crust from the freezer and place it over the prepared pie shell with filling, centering it over the pie pan. Let it warm up until it's just softened so you can then carefully trim around the edge with scissors, cutting right along the edge of the pie pan. Press the cut edge with your fingers so it is smooth and even with the pan, as shown on page 60.

Place the pie in the refrigerator for at least 30 minutes before baking. This will keep the lattice from distorting when it begins to bake. Preheat the oven to 400°F (200°C) with the rack in the bottom position.

Before baking, return the pie to the work surface. Using the small paintbrush, carefully apply the egg wash to the white strips only. Place the pie in the oven and bake as directed (see page 32). If the decorations begin to brown excessively, loosely cover the pie with a sheet of aluminum foil or a pie shield. Remove from the oven and let cool on a cooling rack.

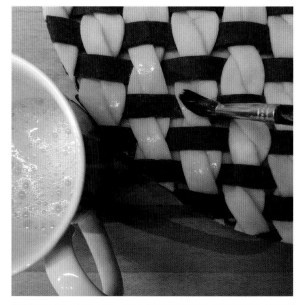

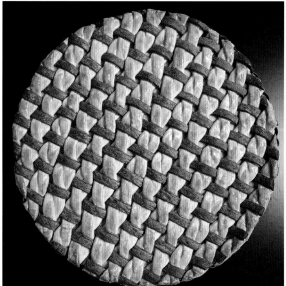

# IMPRESSIONS OF AUTUMN

## MAKES ONE (10 TO 11-INCH/25 TO 28-CM) PIE

*This design marked the beginning of my journey into crust decoration and was extremely popular. It represents the fullness of autumn with the first leaves falling with many flowers still in bloom, including one of my favorites, asters. The crust is not difficult, but it requires accurate layout and five different cookie cutters. I made this with sweet nectarines that needed just a hint of sugar, but you can use any stone fruit, or even apple, that can be arranged decoratively.*

**CRUSTS**

3 recipes Basic Pie Dough (page 14)

**SPECIAL EQUIPMENT**

1¾-inch (4.5-cm) circle cookie cutter

1½-inch (4-cm) circle cookie cutter

Ruler

2 by 2-inch (5 by 5-cm) maple leaf cookie cutter

1 by 2-inch (2.5 by 5-cm) oak leaf cookie cutter

4½ by 1½-inch (11.5 by 4-cm) daisy cookie cutter (see picture at right)

2-inch (5-cm) "5-heart" cookie cutter (see picture at right)

Small artist's paintbrush

**FILLING**

6 to 8 peeled and thinly sliced nectarines

¼ to ½ cup sugar (50 to 100 g) (according to taste and the sweetness of the fruit)

**EGG WASH**

1 egg, beaten with a few drops of water

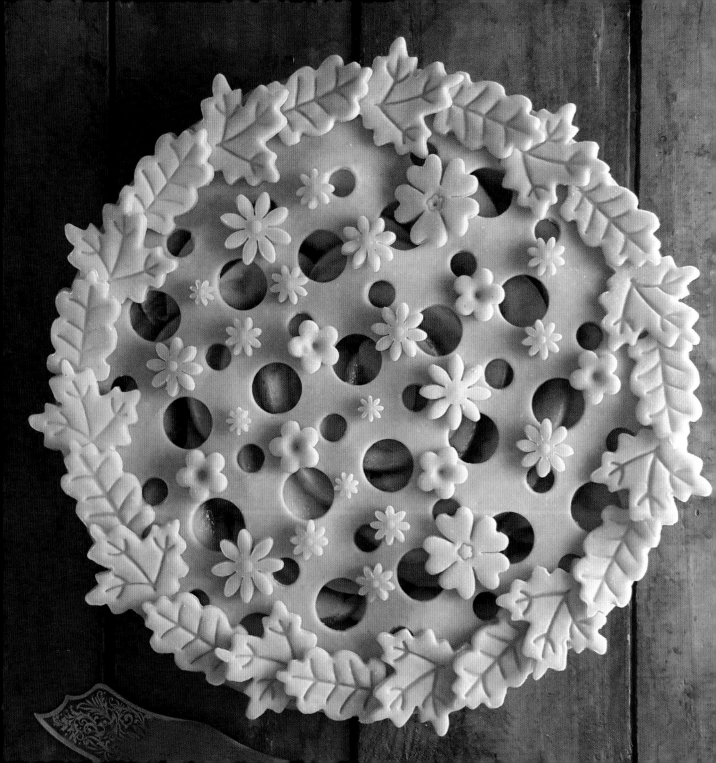

Roll out one batch of dough into a disk about 13 inches (33 cm) in diameter and about ⅛ inch (3 mm) thick to fit the size of your pie pan. Line the pie pan with the bottom crust and carefully place the nectarine slices in concentric circles to form a smooth and attractive top layer. Place the prepared pie shell with fruit in the refrigerator until needed.

Roll out the other two batches of dough into disks about the same size as the first one. Remove any excess flour and then transfer to a pastry lifter to chill in the refrigerator for at least 15 minutes. Once chilled, place one disk of dough on your work surface and trim it to a circle about 11 inches (28 cm) in diameter. Proceed as directed.

**1.** Cut out alternating rows of ¾-inch (20-mm) and ½-inch (12-mm) circles. Keep the rows straight and parallel and make sure the distance between the holes in each row is equal.

**2.** If necessary, smooth out the cut edges of the holes with the tip of a fork handle or similar tool. Place the prepared disk in the freezer until firm, about 30 minutes.

**3.** Remove the prepared pie shell with nectarine slices from the refrigerator and place it on your work surface.

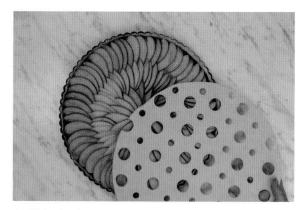

**4.** Slide the frozen upper crust onto the prepared pie shell. When frozen, the disk of dough will be very firm and easy to manipulate.

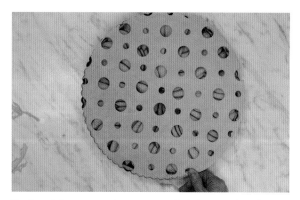

**5.** Carefully center the pattern of circles on the pie pan. After the dough has warmed up and is soft, press around the edge to remove the excess. Place in the refrigerator to chill again.

**6.** Cut out the leaves and place them in a circle around the edge, alternating the leaves as shown.

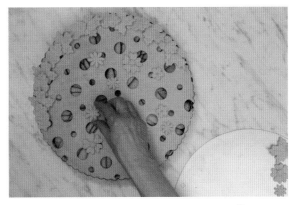

**7.** Cut out the flowers and ornaments, smoothing the edges as necessary.

**8.** Decorate the upper crust with the leaves, flowers, and ornaments as shown here and on page 66.

When you are finished decorating, chill the pie in the refrigerator for at least 1 hour. Preheat the oven to 400°F (200°C) with the rack in the bottom position.

Before baking, return the pie to the work surface. Remove all of the decorations and apply the egg wash to the crust, then replace the decorations and brush them with egg wash as well, using the small paintbrush. Place the pie in the oven and bake as directed (see page 32). If the decorations begin to brown excessively, loosely cover the pie with a sheet of aluminum foil or a pie shield. Remove from the oven and let cool on a cooling rack.

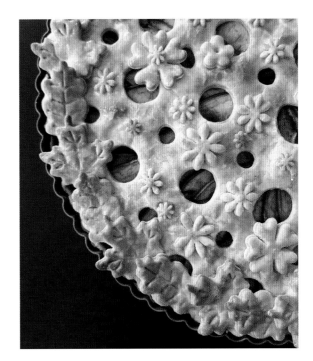

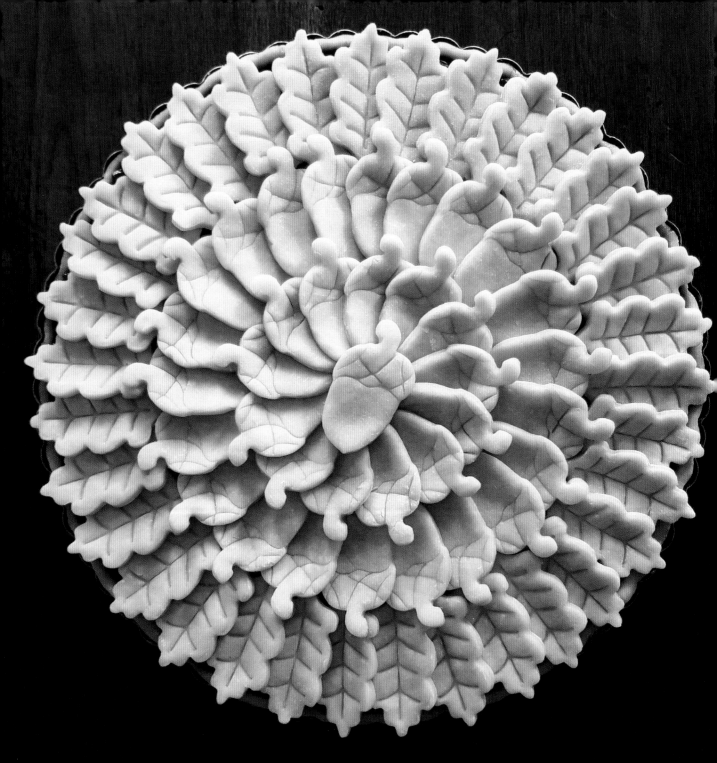

# LITTLE ACORNS AND LEAVES
# OF MIGHTY OAK

*This is a wonderful pie for autumn or early winter and is relatively easy to make. You can use this top crust on almost any filling, but be careful not to overfill the pie shell.*

1 prepared pie shell with bottom crust and filling of your choice (page 26) in a 13-inch (33-cm) tart pan with fluted edge and no lip

TOP CRUST
2 recipes Basic Pie Dough (page 14)

SPECIAL EQUIPMENT
1 by 2-inch (2.5 by 5 cm) acorn cookie cutter
1 by 2¼-inch (2.5 by 6 cm) oak leaf cookie cutter
Small artist's paintbrush

EGG WASH
1 egg, beaten with a few drops of water

Keep your prepared pie shell with filling in the refrigerator. Roll out both batches of dough into disks somewhat thicker than ⅛ inch (3 mm), which will allow the cookie cutters to more deeply emboss the surface. Test using your cutters to see which thickness gives the best results. Adjust the thickness as needed. Dust with a brush to remove any excess flour and then transfer both disks to lightly floured pastry lifters. Chill in the refrigerator for at least 15 minutes.

Begin by placing the individual cutout pieces on a pastry lifter for practice, or you can place the pieces directly on the prepared pie shell with filling. Proceed as directed.

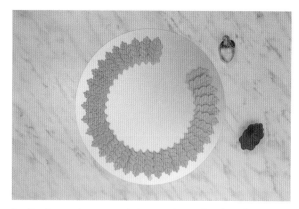

**1.** Begin cutting out oak leaves from the dough disk and place them on a pastry lifter in a circle the size of the pie pan you will be using.

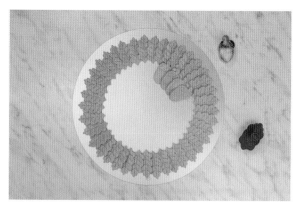

**2.** When the circle is complete, begin cutting out the acorns and placing them in a concentric circle inside the leaves as shown.

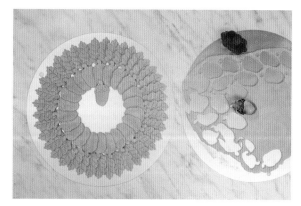

**3.** Continue adding acorns, overlapping them by about one-third of their width. Use the second disk of rolled-out dough as needed.

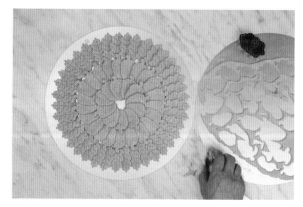

**4.** Begin a second row of acorns overlapping just a little more to create a smaller circle. When the second circle of acorns is complete, place one more acorn in the center.

If you practiced on a pastry lifter, place the cutouts in the refrigerator to chill. Preheat the oven to 400°F (200°C) with the rack in the bottom position.

Transfer the chilled dough pieces to the top of the filling on the pie shell in the same order as shown. Once in place, carefully apply the egg wash with the small paintbrush. Place the pie in the oven and bake as directed (see page 32). If the decorations begin to brown excessively, loosely cover the pie with a sheet of aluminum foil or a pie shield. Remove from the oven and let cool on a cooling rack.

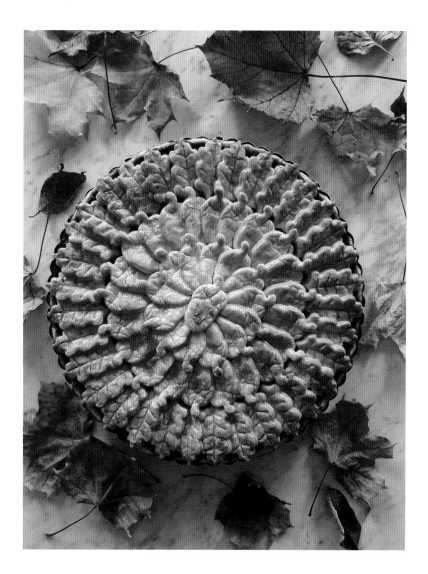

# A CHOCOLATE DREAM

*I've heard a few people say they don't like chocolate, but only very few! Chocolate is so popular that when I serve this pie, there are never more than a few crumbs of the crust left. This pie uses two different crust recipes: one for the bottom and one for the top. For the bottom, I make the Cookie Crumb Pie Crust using vanilla wafers. Graham crackers or other cookies work just as well. The top crust decoration is made from Basic Pie Dough. The designs shown here are just suggestions. Use your imagination to dream up the top decoration by choosing any size or shape of cookie cutters for flowers, leaves, hearts, or whatever you like.*

**BOTTOM CRUST**

1 recipe Cookie Crumb Pie Crust (page 22)

**FILLING**

1 recipe Creamy Dark Chocolate Pie Filling (page 31)

**TOP CRUST**

1 recipe Basic Pie Dough (page 14)

**SPECIAL EQUIPMENT**

1 round pastry lifter or large plate about 12 inches (30 cm) in diameter

Rolling cutter

Various small flower-shaped cookie cutters and leaf-shaped cookie cutters or other decorative cutters of your choice

Small artist's paintbrush

**EGG WASH**

1 egg, beaten with a few drops of water

Prepare and bake the bottom cookie crust. While it's cooling, prepare the chocolate filling and bake as directed (see page 31). Remove from the oven and let cool.

To make the decorative top crust, roll out the dough into a disk about 13 inches (33 cm) in diameter and ⅛ inch (3 mm) thick. Place the disk onto a cutting mat, pastry lifter, or your work surface, and proceed as directed.

**1.** Place the round pastry lifter or large plate over about ⅓ of the disk and cut along the edge to create a half-moon-shaped segment.

**2.** Using the leftover dough, cut three curved strips and braid them, keeping the braid flat. After cutting the braid to length, place it on the half-moon dough sheet, parallel to the curved edge.

**3.** Use cookie cutters to cut out flowers, leaves, or other objects from the remaining dough and place them on top of the half-moon dough shape.

**4.** This is just a suggestion of what the decorative crust might look like when you are finished. Chill the crust for 15 minutes, and then apply the egg wash with the small paintbrush. Preheat the oven to 375°F (190°C) with the rack in the middle position. Bake for 30 minutes or until brown.

**5.** Once baked, transfer the top crust to a cooling rack to cool.

**6.** When cool, place the top crust on the pie in any position you like.

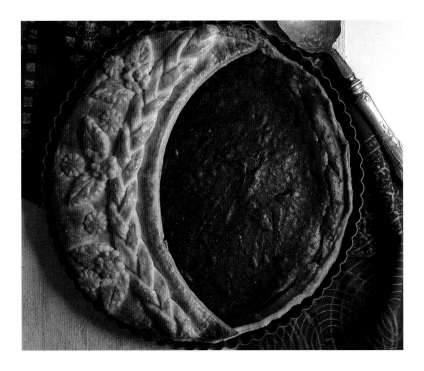

# Intermediate Projects

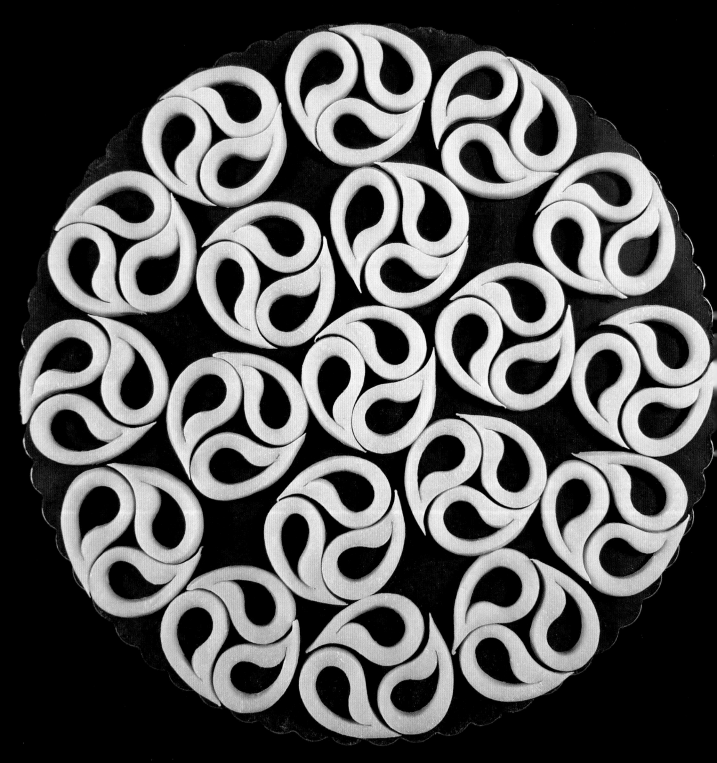

# CRIMSON PIE WITH PAISLEY CIRCLES

## MAKES ONE (13-INCH/33-CM) PIE

*This is a very simple pie to make, and the result is quite impressive. I like the idea of a brilliant red background, so I chose red (beet) pie dough, but this could also be very attractive with a vibrant purple background using blueberry coloring (see page 18). I use a wild (sour) cherry pie filling (see page 29), but you can use almost any other filling.*

1 prepared pie shell with bottom crust and filling of your choice (page 26) in a 13-inch (33-cm) tart pan with fluted edge and no lip

**TOP CRUST**

½ recipe Red (Beet) Pie Dough (page 20) or colored dough of choice

2 recipes Basic Pie Dough (page 14)

**SPECIAL EQUIPMENT**

1-inch (2.5-cm) paisley cookie cutter

1½-inch (4-cm) paisley cookie cutter

Palette knife or long knife with thin blade

Small artist's paintbrush

**EGG WASH**

1 egg, beaten with a few drops of water

Keep your prepared pie shell with filling in the refrigerator. Roll out the red dough into a disk about 1 inch (2.5 cm) larger than the pie pan you're using and ⅛ inch (3 mm) thick. When rolling out the red dough, use as little flour as possible on the work surface so the dough doesn't drastically change color. Once the dough is rolled out, trim it to about 11 inches (28 cm) in diameter and transfer it to a lightly floured pastry lifter. Place in the refrigerator to chill for about 15 minutes.

Once chilled, remove both the prepared pie shell with filling and the red top crust from the refrigerator and place on your work surface. Transfer the red dough disk to the top of the prepared pie shell by carefully sliding it into place. Carefully trim the dough so that it's even with the edge of the pan. Dust the red top crust with a brush to remove any excess flour. Place the pie back in the refrigerator.

Roll out both batches of basic dough into round disks about 13 inches (33 cm) in diameter and ⅛ inch (3 mm) thick. Transfer the disks to a lightly floured pastry lifter and place them in the refrigerator for 15 minutes. Remove one disk from the refrigerator and place it directly on a lightly floured work surface and proceed as directed. When you've used up all the dough from the first disk, remove the second one from the refrigerator and continue with the next steps.

**1.** Use the large paisley cutter to cut out several shapes. Then use the smaller paisley cutter to cut out the center of each shape. Arrange three of these paisley elements in a circle as shown and repeat.

**2.** Place the paisley circles on a pastry lifter to make sure you have enough to fit the diameter of the pie pan you're using.

**3.** Remove the prepared red crust and arrange the paisley circles in a pattern on top.

**4.** The best way to arrange the circles is to begin at the edge and continue around the periphery of the pie. Continue until the top of the crust is filled with paisley circles.

Once the area is filled with the paisley circles, carefully adjust and arrange as shown on page 78.

Place the prepared pie in the refrigerator for 30 minutes. Preheat the oven to 400°F (200°C) with the rack in the bottom position.

Before baking, return the pie to the work surface. Using the small paintbrush, carefully apply the egg wash to the paisley circles. Place the pie in the oven and bake as directed (see page 32). If the decorations begin to brown excessively, loosely cover the pie with a sheet of aluminum foil or a pie shield. Remove from the oven and let cool on a cooling rack.

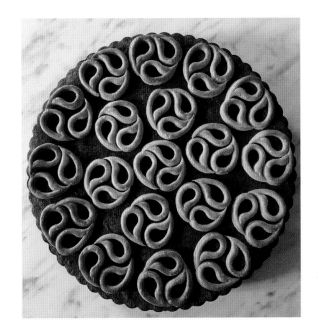

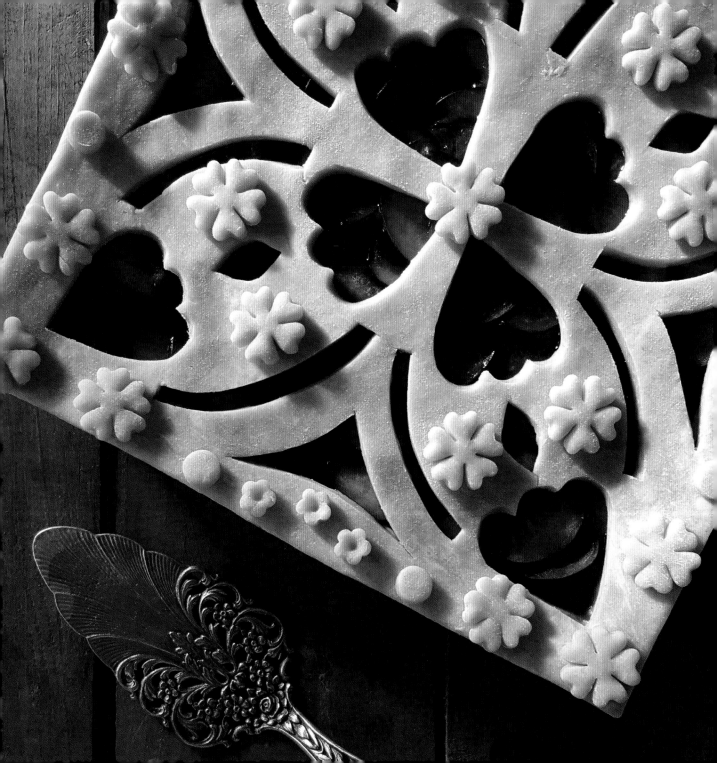

# PORTUGUESE AZULEJOS TILE

## MAKES ONE (9-INCH/23-CM) SQUARE PIE

*This design is my interpretation of the wonderful blue azulejos tiles of Portugal and is guaranteed to surprise and delight your guests. Square pie or tart pans with loose bottoms are available in either a 9-inch (23-cm) or 10-inch (25-cm) size. As with all loose-bottom pans, you must be sure that your bottom crust doesn't have any holes or cracks, or the filling will leak out.*

1 prepared pie shell with bottom crust and filling of your choice (page 26) in a 9-inch (23-cm) square pie or tart pan

**TOP CRUST**

2 recipes Basic Pie Dough (page 14)

All-purpose flour, for rolling out the dough

**SPECIAL EQUIPMENT**

Scalpel or craft knife

1 copy of the top crust design template (page 155), printed to the appropriate size for the pan

Straight pins

¾-inch (4-mm) five-heart cookie cutter

½-inch (12-mm) circle cookie cutter

¼-inch (6-mm) mini-flower cookie cutter

Small artist's paintbrush

**EGG WASH**

1 egg, beaten with a few drops of water

Keep your prepared pie shell with filling in the refrigerator. Roll out both batches of dough into round disks about 12 to 13 inches (30 to 33 cm) in diameter and ⅛ inch (3 mm) thick. Dust with a soft brush to remove any excess flour. Transfer the disks to lightly floured pastry lifters and place them in the refrigerator to chill for 15 minutes.

Once chilled, remove both the prepared pie shell with filling and one of the disks from the refrigerator and place on your work surface. Proceed as directed.

**1.** Using a scalpel, cut out all of the open spaces of the paper template.

**2.** Place the template on your rolled-out disk of dough. If desired, the template can be held in place with pins. Cut out all open spaces of the dough using the template as your guide.

**3.** Cut out the five-heart figures, circles, and flowers from the second disk of dough using your cookie cutters. Carefully smooth the edges before placing on top of the top crust. Transfer the top crust from the cutting mat to a pastry lifter and chill as many times as necessary to keep the dough from getting too warm and soft while you work. When finished, place the complete crust on a lightly floured pastry lifter in the freezer until it is completely firm.

**4.** Carefully transfer the frozen top crust to the top of the prepared pie shell with filling. Replace or reposition any decorations as needed.

When you've used up all the dough from the first disk, remove the second one from the refrigerator and continue with the remaining steps.

Place the entire pie in the refrigerator for 15 minutes to chill. Preheat the oven to 400°F (200°C) with the rack in the bottom position.

Before baking, return the pie to the work surface. Using the small paintbrush, carefully apply the egg wash to the surface decorations. Place the pie in the oven and bake as directed (see page 32). If the decorations begin to brown excessively, loosely cover the pie with a sheet of aluminum foil or a pie shield. Remove from the oven and let cool on a cooling rack.

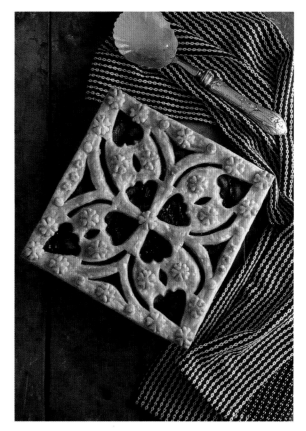

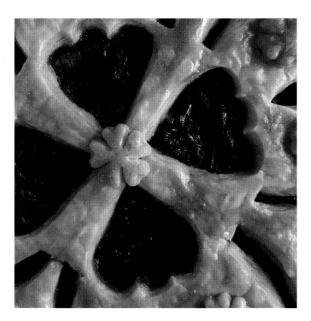

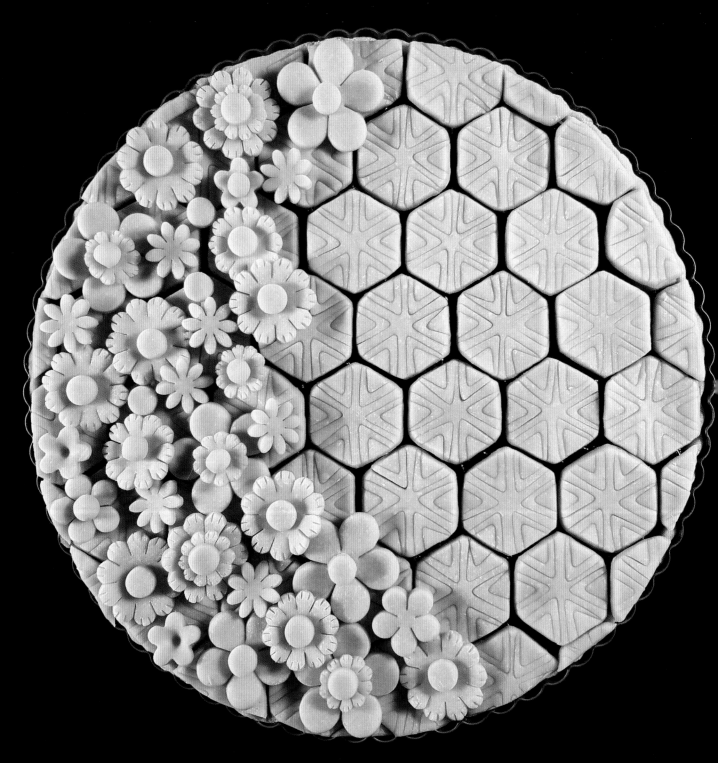

# A GARDEN OF FLOWERS AND HEXAGONS

*This design is such a joy to make, and the result is truly beautiful. The geometric hexagons are perfectly balanced by the field of flowers. Use your imagination with the flowers, either cutting them freehand or using cookie cutters. Using a combination of flower and circle cutters will help you create your own custom flower designs. Use any type of filling you like, as long as it's not lumpy and can be smoothed out on the surface. I used a large 13-inch (32-cm) pie pan so that there was plenty of room to decorate the top crust, but you can scale this down to 11 inches (28 cm) if you prefer. However, I wouldn't make it any smaller or it will look crowded.*

1 prepared pie shell with bottom crust and filling of your choice (page 26) in a 13-inch (33-cm) tart pan with fluted edge and no lip

**TOP CRUST**

2 recipes Basic Pie Dough (page 14)

**SPECIAL EQUIPMENT**

1½-inch (4-cm) hexagon-shaped cookie cutter

1 by 2-inch (2.5 by 5-cm) rhombus (diamond) cookie cutter

Scissors

Flower and circle cookie cutters, different sizes

Small artist's paintbrush

**EGG WASH**

1 egg, beaten with a few drops of water

Keep your prepared pie shell with filling in the refrigerator. Roll out both batches of dough into round disks about 12 to 13 inches (30 to 33 cm) in diameter and ⅛ inch (3 mm) thick. Dust with a soft brush to remove any excess flour. Transfer the disks to lightly floured pastry lifters and place them in the refrigerator to chill for 15 minutes.

Once chilled, remove one of the disks from the refrigerator and place it on your work surface. Begin by cutting out hexagons with the appropriate cutter. Smooth the edges with your fingers. If the bottom surface looks more appealing, you can turn the hexagons over so the bottom side is up. Emboss the hexagons by pressing the rhombus cutter into each of the six edges two times to create the geometric pattern as shown in step 1.

**1.** After cutting out the hexagons, emboss each by pressing one end of the rhombus cutter into each side of the hexagon twice as shown.

**2.** Place the hexagons in a honeycomb pattern and trim the edge with scissors to fit the size of your pie pan. Transfer the entire top crust to a pastry lifter and then to the refrigerator to chill.

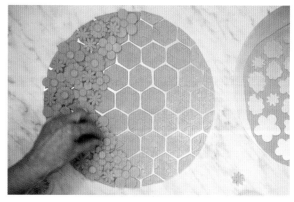

**3.** Remove the second disk of dough from the refrigerator and cut out the flowers as desired. Using your imagination, you can create any number of custom and unique designs by combining cutouts.

**4.** Arrange the flowers in a half-moon pattern on the hexagons to cover approximately ⅓ of the diameter of the pie. Place in the refrigerator to chill for at least 1 hour.

Transfer the prepared pie shell with filling and the decorations on the pastry lifter to your work area. Remove the flowers from the hexagons and then begin transferring the hexagons individually to the top of the pie, keeping the arrangement as accurate as possible. The hexagons can be placed relatively close together, as they will shrink while baking. Place the flowers on top of the hexagons. When you are satisfied with the arrangement, chill your fully decorated pie in the refrigerator for 1 hour or overnight.

When ready to bake, preheat the oven to 400°F (200°C) with the rack in the bottom position.

Before baking, return the pie to the work surface. Using the small paintbrush, carefully apply the egg wash to the decorations. Place the pie in the oven and bake as directed (see page 32). If the decorations begin to brown excessively, loosely cover the pie with a sheet of aluminum foil or a pie shield. Remove from the oven and let cool on a cooling rack.

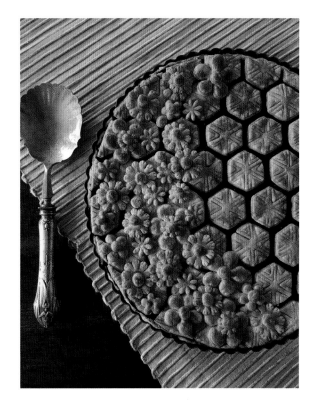

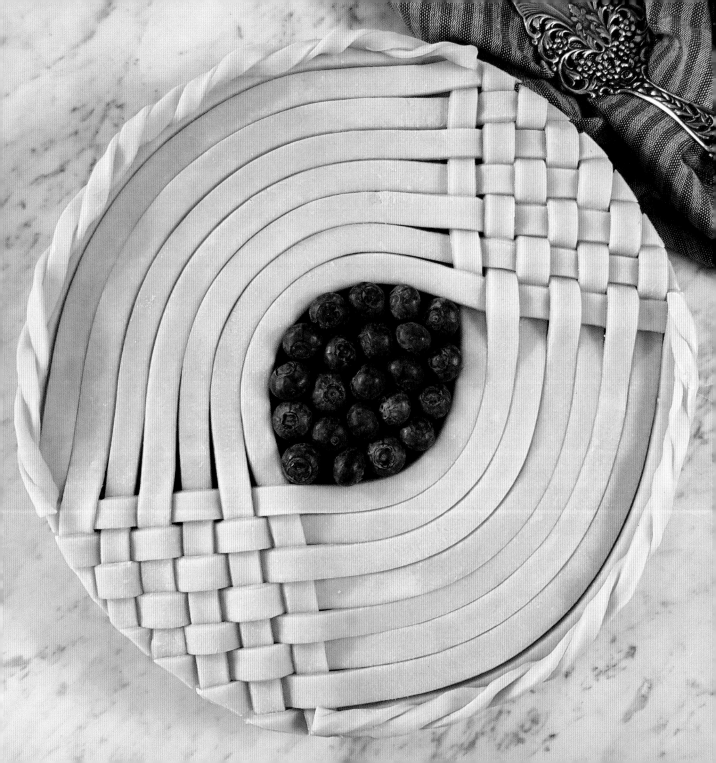

# EYE IN THE PIE

## MAKES ONE (11 TO 12-INCH/28 TO 30-CM) PIE

*I often try to work with variations of lattices since they are so suitable for covering a pie. In this case, I used two sections of lattice and left an opening with strips above and below. After I had finished, I realized that the design looked a little bit like an eye. This pattern is perfect if you have some beautiful blueberries, raspberries, or blackberries to show off. While it's not difficult, it requires careful assembly so that the rows of strips are even and parallel.*

1 prepared pie shell with bottom crust and cherry (page 29), apple (page 27), or filling of your choice (page 26)

### TOP CRUST

2 recipes Basic Pie Dough (page 14)

Fresh berries

### SPECIAL EQUIPMENT

Rolling cutter

Ruler

Scissors

Small artist's paintbrush

### EGG WASH

1 egg, beaten with a few drops of water

Keep your prepared pie shell with filling in the refrigerator. Roll out both batches of dough into round disks about 13 inches (33 cm) in diameter and ⅛ inch (3 mm) thick. Dust with a soft brush to remove any excess flour. Transfer the disks to lightly floured pastry lifters and place them in the refrigerator to chill for 15 minutes.

When chilled and firm, remove both disks from the refrigerator. Using a rolling cutter and ruler, cut both disks into ½-inch (12-mm) strips until you have at least 18 strips. Proceed as directed.

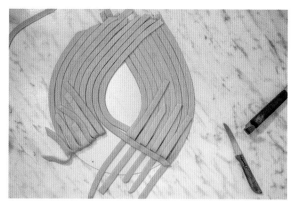

**1.** Lay the strips out, with nine on each side. Flip over all the left-hand strips at the bottom and every other one on the right. Place strips from the left over the strips on the right to create a lattice pattern.

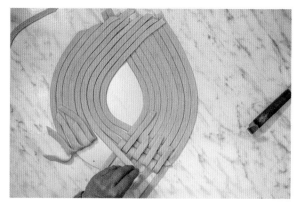

**2.** Keep the lattice work tight as you work, adding strips from the left over the alternating strips on the right.

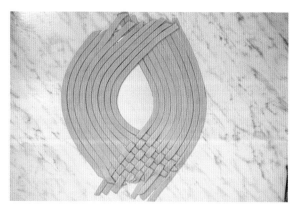

**3.** Make certain your lattice is tight and even, and then turn the top crust around so that the other ends are now facing you.

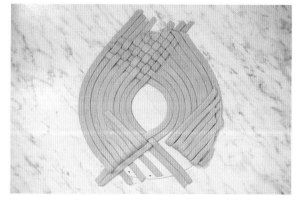

**4.** Begin creating the same kind of weave with the strips, but now work from right to left so that the design is balanced.

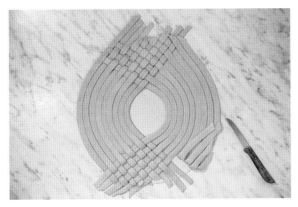

**5.** Continue with the second lattice until all strips are used.

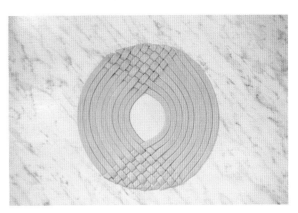

**6.** When complete, trim the edges to a diameter somewhat larger than the pie pan you're using. Then place in the freezer for at least 30 minutes.

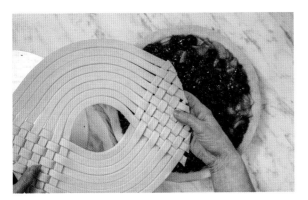

**7.** When the top crust is frozen and completely firm, transfer to the prepared pie shell.

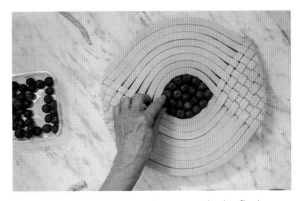

**8.** Once the crust is thawed, you can do the final trimming with scissors. Then place the blueberries in the middle of the pie.

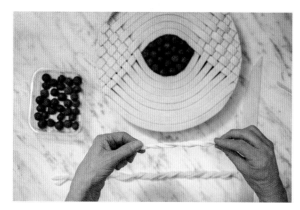

**9.** Cut four thin strips from the remaining dough and twist them together to create an edge decoration.

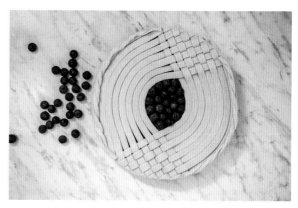

**10.** Check the crust for evenness.

Place the prepared pie in the regrigerator for 30 minutes. Preheat the oven to 400°F (200°C) with the rack in the bottom position.

Before baking, return the pie to the work surface. Using the small paintbrush, carefully apply the egg wash to the top of the crust. Place the pie in the oven and bake as directed (see page 32). If the decorations begin to brown excessively, loosely cover the pie with a sheet of aluminum foil or a pie shield. Remove from the oven and let cool on a cooling rack.

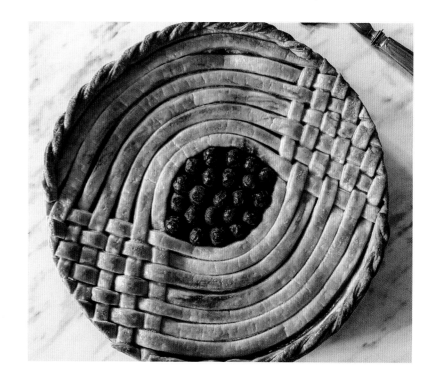

# REFLECTIONS OF SUMMER

## MAKES ONE (11 TO 13-INCH/28 TO 33-CM) PIE

*Carnations are always gorgeous, both in the garden and in a vase. This pie design shows their beauty as reflections and flowers, with a little foliage in between. This is not a difficult design and quite attractive, especially if you are using red or blue fruit, such as cherries or blueberries, that show through on the open side.*

1 prepared pie shell with bottom crust and cherry filling (page 29) in a tart pan with fluted edge and no lip

**TOP CRUST**

2 recipes Basic Pie Dough (page 14)

**SPECIAL EQUIPMENT**

Paring knife

Ruler

1½-inch (4-cm) carnation cookie cutter

Scalpel or craft knife handle or other round object the size of a pencil

½-inch (12-mm) circle cookie cutter

1½-inch (4-cm) beech leaf cookie cutter

Small artist's paintbrush

**EGG WASH**

1 egg, beaten with a few drops of water

Keep your prepared pie shell with filling in the refrigerator. Roll out both batches of dough into round disks about 13 inches (33 cm) in diameter and ⅛ inch (3 mm) thick. Dust with a soft brush to remove any excess flour. Transfer the disks to lightly floured pastry lifters and place them in the refrigerator to chill for 15 minutes.

Once chilled, remove one of the disks from the refrigerator and place on your work surface. Proceed as directed.

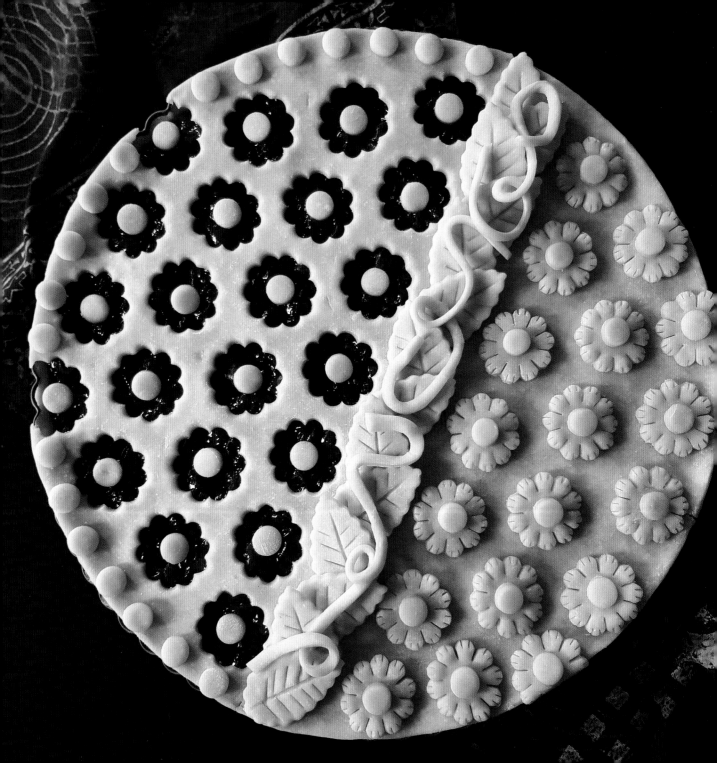

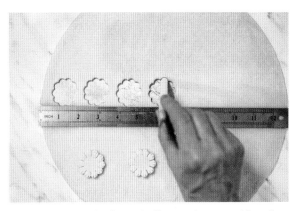

**1.** Cut the dough disk to fit your pie pan. Place the ruler across the center of the disk and begin cutting out carnations with the cookie cutter, leaving about ½ inch (12 mm) between the flowers.

**2.** Using the back of your knife, or other round handle, smooth the indentations of the openings from the flowers.

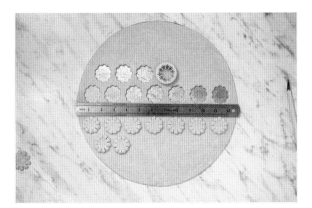

**3.** Continue cutting out and smoothing the carnations until the top half of the disk is completely cut out. Place the cutout flowers below the ruler as shown. Place in the freezer.

**4.** Transfer the second dough disk from the refrigerator to your work surface. Using the ½-inch (12-mm) round cutter, cut out small circles to use for the centers of the flowers.

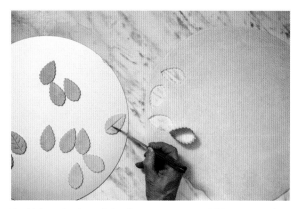

**5.** Using the beech leaf cutter, cut out 14 leaves and emboss the veins in the leaves using the back of a paring knife.

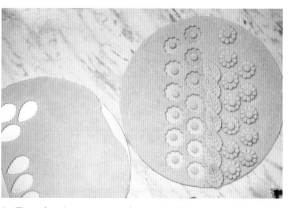

**6.** Transfer the top crust from the freezer to your work area. Place the leaves in between the two halves. Continue to cut out and place the carnations on the top crust disk.

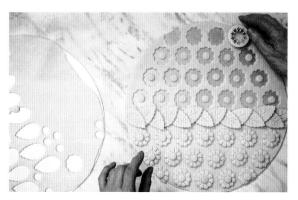

**7.** Finish cutting out and placing the leaves, carnations, and the small center dots.

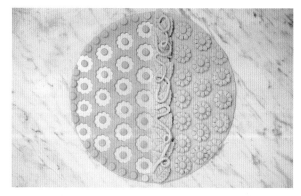

**8.** When finished, cut out thin "vines" about ¼ inch (6 mm) thick and 8 inches (20 cm) long to wind over the leaves in the middle. Place the finished top crust in the freezer for at least 30 minutes or until firm.

**9.** Transfer the frozen top crust to your work area.

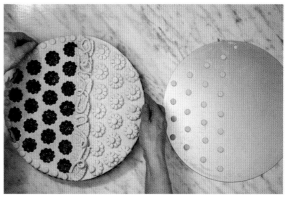

**10.** Leaving the small circles on the pastry lifter, transfer the crust to the top of the prepared pie with filling. Then transfer the dots, placing them in the centers of the flower-shaped openings.

Place the prepared pie in the refrigerator for 30 minutes. Preheat the oven to 400°F (200°C) with the rack in the bottom position.

Before baking, return the pie to the work surface. Using the small paintbrush, carefully apply the egg wash to the dough decorations. Place the pie in the oven and bake as directed (see page 32). If the decorations begin to brown excessively, loosely cover the pie with a sheet of aluminum foil or a pie shield. Remove from the oven and let cool on a cooling rack.

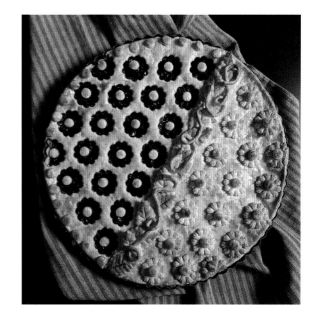

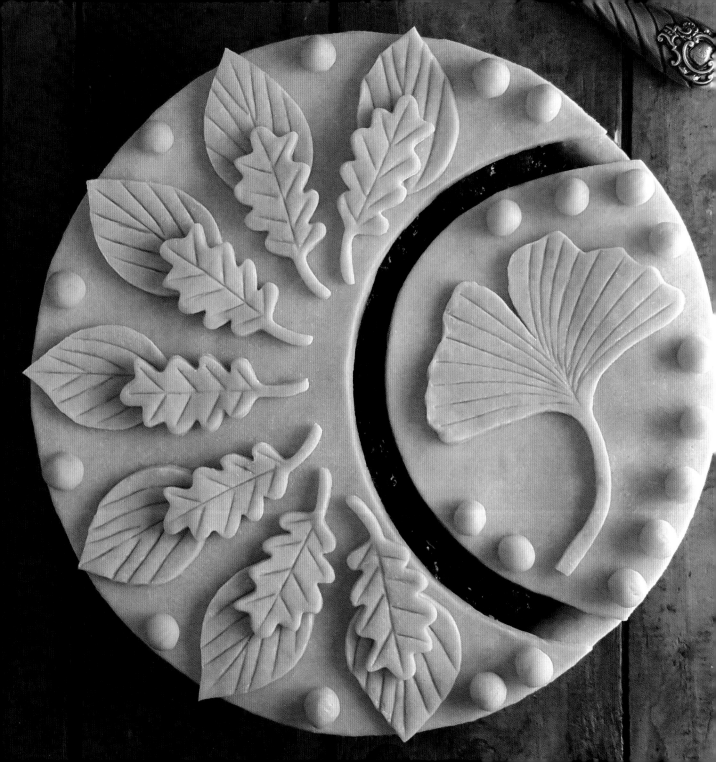

# GINKGO BILOBA

This tree's leaf, that from the East
Has been entrusted to my garden,
Gives to savor secret sense,
As pleasing the initiate,

Is it one living creature,
Which separated in itself?
Are they two, who choose themselves,
To be recognized as one?

Such query to reciprocate,
I surely found the proper use,
Do not you feel it in my songs,
That I am one and double?

*This poem by Johann Wolfgang von Goethe describes the dual nature of love and friendship, comparing it to the equally dual leaf of the gingko tree. This has long been a favorite poem of mine, so I created this pie in its honor, using a real leaf from the gingko tree in our garden as the template. The oak leaves are pressed out using a cookie cutter, and the beech leaves are hand cut. You can apply this crust design to almost any pie filling. I have chosen cranberry and orange filling because it's ideal for autumn and Thanksgiving.*

1 prepared pie shell with bottom crust and cherry filling (page 29) or filling of your choice (page 26)

**TOP CRUST**

3 recipes Basic Pie Dough (page 14)

**SPECIAL EQUIPMENT**

Gingko and beech tree leaf templates (page 156)

Scissors

9-inch (23-cm) salad plate

Scalpel or craft knife

Paring knife

1½-inch (4-cm) oak leaf cookie cutter

Small artist's paintbrush

**EGG WASH**

1 egg, beaten with a few drops of water

Copy the leaf templates and print to a length of 4⅛ inches (11 cm), then carefully cut out using scissors or a knife on a cutting board.

Keep your prepared pie shell with filling in the refrigerator. To make the top crust, roll out one batch of dough into a round disk about 13 inches (33 cm) in diameter and ⅛ inch (3 mm) thick. Dust with a soft brush to remove any excess flour. Transfer the disk to a lightly floured pastry lifter and place it in the refrigerator to chill for 15 to 30 minutes.

Once chilled, remove both the prepared pie shell with filling and the disk from the refrigerator and place on your lightly floured work surface or cutting mat. Proceed as directed.

**1.** Lay the ginkgo leaf template on the dough disk as shown. Then, using a 9-inch (23-cm) salad plate as a guide, cut out the sector around the template.

**2.** Carefully make a second, parallel cut to create a gap of about ½ inch (12 mm) between the two parts of the top crust. Chill the two parts of the top crust in the refrigerator while proceeding with the decoration.

Roll out a second batch of dough into a round disk about 13 inches (33 cm) in diameter and ⅛ inch (3 mm) thick. Remove any excess flour and transfer to a lightly floured pastry lifter. Chill in the refrigerator for 15 to 30 minutes. Transfer to your lightly floured work surface or to a cutting mat and proceed as directed.

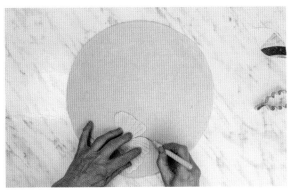

**3.** Place the template on the rolled-out dough disk and carefully trace around it with a scalpel.

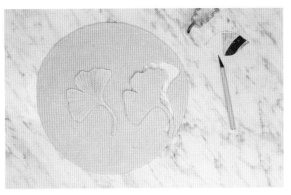

**4.** Carefully remove the leaf, recutting any spots you might have missed. If necessary, smooth the edges of the leaf with your fingers.

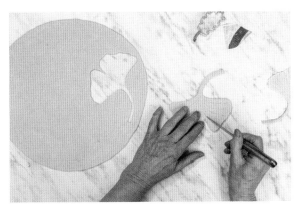

**5.** Emboss the leaf as shown on the template by pressing lightly with the back of a paring knife.

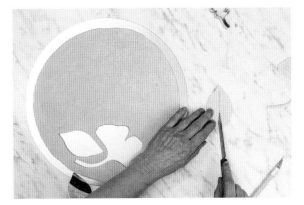

**6.** Cut out seven simple leaves with a scalpel and smooth the edges. Emboss the central vein with the back of the paring knife.

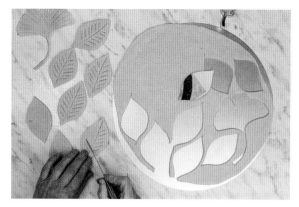

**7.** Continue embossing the outer veins of the leaves.

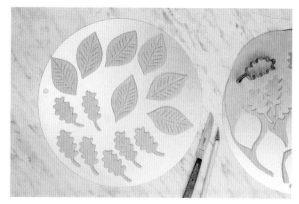

**8.** Using the cookie cutter, cut out the oak leaves and smooth out the edges with your fingers.

Transfer the top crust from the refrigerator to your work area and proceed as directed.

**9.** Place the ginkgo leaf in the center of the small segment of the circle.

**10.** Begin placing the leaves around the outer edge of the large segment as shown.

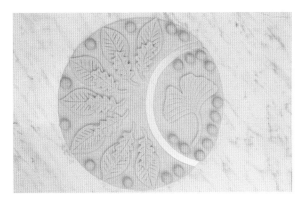

**11.** Carefully arrange the leaves so they are equidistant from one another.

**12.** Prepare 21 small balls ½ inch to ¾ inch (12 mm to 20 mm) in diameter from the scraps of dough left over from the decorations. Then place them around the top crust as shown. When fully prepared, freeze the crust until firm.

Preheat the oven to 400°F (200°C) with the rack in the lowest position.

Place both the prepared pie shell with filling and the prepared top crust on your work surface. Carefully transfer both halves of the top crust to the top of the pie shell. When frozen, it's very easy to move the top crust, but first carefully remove the balls and then replace them after the top crust is in place. When the crust has thawed, apply the egg wash on the decorations and underneath the balls using a small paintbrush.

Place the pie in the oven and bake as directed (see page 32). If the decorations begin to brown excessively, loosely cover the pie with a sheet of aluminum foil or a pie shield. Remove from the oven and let cool on a cooling rack.

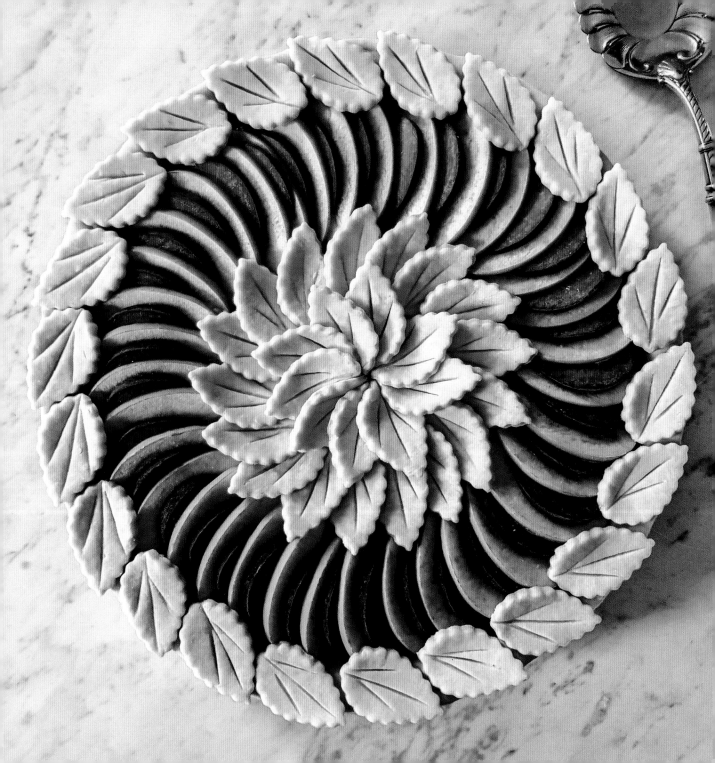

# THE BEAUTY OF FRUIT

## MAKES ONE (11-INCH/28-CM) PIE

*When you place this pie on the table, your guests will definitely be stunned. This is a great opportunity to show off your pie skills with beautiful apples and plums over a bed of sweet or sour cherries. As an exception to my rule of peeling apples, I chose not to peel the Granny Smith apples to show off their color; however, not everyone will enjoy the peels, so you can peel them if you prefer. To keep their round shape, it is best to use a peeler instead of a knife. This crust design requires the fruit to be cut very carefully into equally thick slices. Place the slices very accurately in a circle to create a mesmerizing effect.*

1 prepared pie shell with bottom crust and sour cherry filling (page 29)

2 to 4 Granny Smith or other green-skinned apples

8 to 10 red plums

**CRUSTS**

2 recipes Basic Pie Dough (page 14)

**SPECIAL EQUIPMENT**

1 by 1½-inch (2.5 by 4-cm) leaf cutter of your choice (I used an apple leaf)

Paring knife

Small artist's paintbrush

**EGG WASH**

1 egg, beaten with a few drops of water

Keep your prepared pie shell with filling in the refrigerator. Roll out both batches of dough into round disks about 12 to 13 inches (30 to 33 cm) in diameter and ⅛ inch (3 mm) thick. Dust with a soft brush to remove any excess flour. Transfer the disks to lightly floured pastry lifters and place them in the refrigerator to chill for 15 minutes.

The green apples can be left unpeeled or peeled. Carefully cut them into very thin wedges. This requires a very sharp and thin knife blade. If you wish to cut them all at once, you can drizzle them with lemon juice to keep them from discoloring. Cut the plums into similar-size slices, remove the pie with filling from the refrigerator, and proceed as directed.

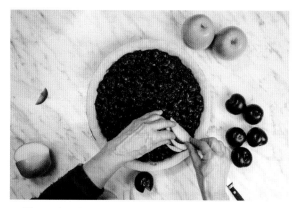

**1.** Place the thin wedges on the filling, alternating apple and plum.

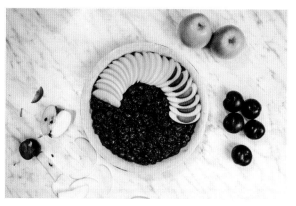

**2.** Continue making your pattern of alternating wedges of apple and plum around the periphery of the pie.

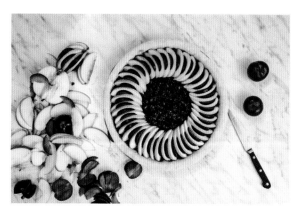

**3.** Adjust the circle of fruit wedges to finish the design.

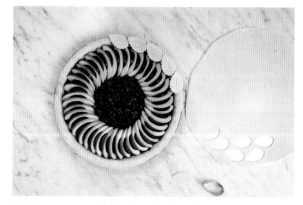

**4.** Remove one of the dough disks from the refrigerator and place on a lightly floured work surface. Cut out the decorative leaves using the cookie cutter. Emboss the veins using the back of a paring knife.

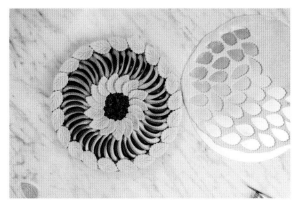

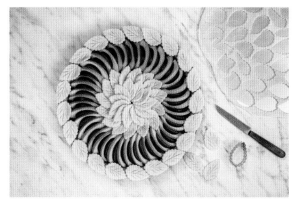

**5.** Use the second disk of dough as needed to cut additional leaves. Carefully arrange the leaves in the middle so they form a circular shape.

**6.** Add another circle of leaves to the center. Check and adjust the arrangement and add the leaves to the periphery as shown.

When all of the fruit and the decorations are in place, put the pie in the freezer for 15 minutes. Preheat the oven to 400°F (200°C) with the rack in the bottom position.

Before baking, return the pie to the work surface. Using the small paintbrush, carefully apply the egg wash to the leaves. Place the pie in the oven and bake as directed (see page 32). If the decorations begin to brown excessively, loosely cover the pie with a sheet of aluminum foil or a pie shield. Remove from the oven and let cool on a cooling rack.

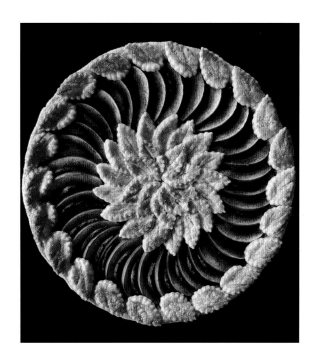

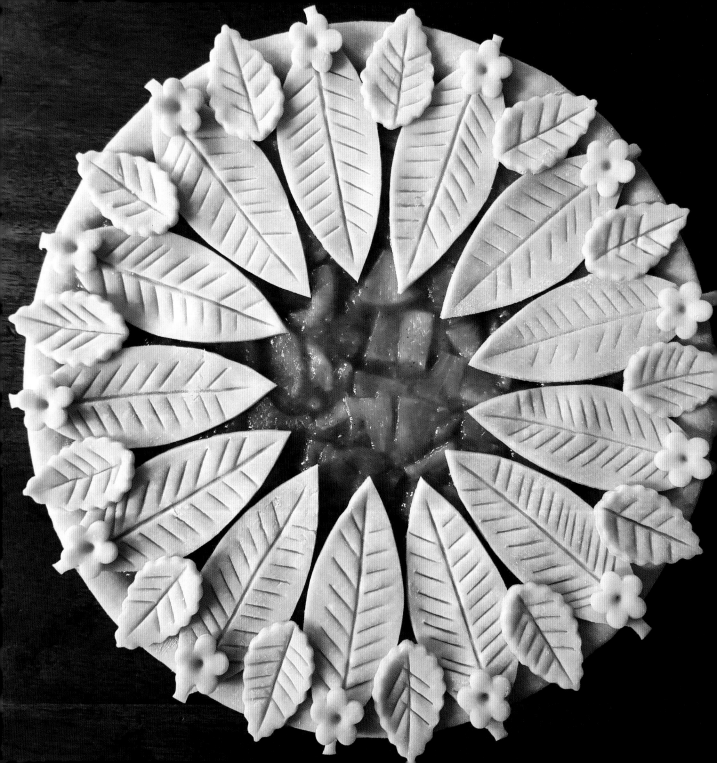

# BEECHES, BIRCHES, AND BLOSSOMS

*This is a wonderfully simple design. The opening at the center of the pie gives a good view of the filling and spreads the delicious aroma of baking fruit throughout the whole house. This is a perfect summer design. Beech trees, birch trees, and tiny daisies are prevalent in the summer where I live, so I chose those designs. You can select both the leaves and the flowers according to your own taste or to reflect the flora where you live.*

1 prepared pie shell with bottom crust and filling of your choice (page 26)

**TOP CRUST**

2 recipes Basic Pie Dough (page 14)

**SPECIAL EQUIPMENT**

Leaf template (page 157) or fresh tree leaves as templates

Scalpel or craft knife

Paring knife

1¾-inch (4.5-cm) birch leaf cookie cutter

½-inch (12-mm) mini-flower cookie cutter, or other leaves and flowers of your choice

Small artist's paintbrush

**EGG WASH**

1 egg, beaten with a few drops of water

Keep your prepared pie shell with filling in the refrigerator until ready to use. Roll out both batches of dough into round disks about 13 inches (33 cm) in diameter and ⅛ inch (3 mm) thick. Dust with a soft brush to remove any excess flour. Transfer one disk to a lightly floured pastry lifter and place in the refrigerator to chill for at least 15 minutes. Transfer the second disk to your work surface and proceed as directed.

**1.** Remove the pie crust with filling from the refrigerator and carefully smooth out the filling in your pie shell. The smoother the filling, the more attractive your decorations will look. Place the prepared pie shell back in the refrigerator until needed.

**2.** Using the template or your fresh tree leaf, carefully cut out enough leaves to cover the circumference of your pie pan. For my 11-inch (28-cm) pan and chosen leaf cutout, I need 13 leaves.

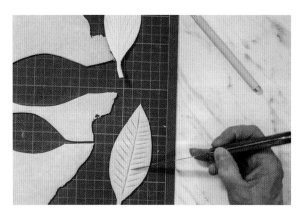

**3.** Use the back of a paring knife to emboss the veins into the leaves.

**4.** Using the birch leaf or other leaf cutter, cut out as many small leaves as you have large leaves.

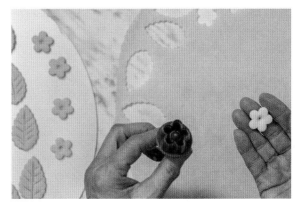

**5.** Using the paring knife, emboss the small leaves with veins.

**6.** Using the mini-flower or other small flower cookie cutter, cut out as many flowers as you have leaves. Smooth the edges of the flowers with your fingers.

Carefully apply the decorations to the top of the pie, beginning with the large leaves, then the small leaves, and finally the flowers. Make certain that the various elements are equidistant from each other and neatly arranged.

Place the pie in the freezer to chill for 15 minutes. Preheat the oven to 400°F (200°C) with the rack in the bottom position.

Before baking, return the pie to the work surface. Using the small paintbrush, carefully apply the egg wash evenly to all areas of decoration. Place the pie in the oven and bake as directed (see page 32). If the decorations begin to brown excessively, loosely cover the pie with a sheet of aluminum foil or a pie shield. Remove from the oven and let cool on a cooling rack.

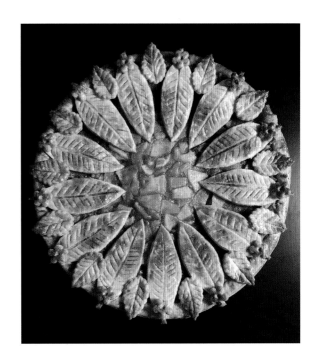

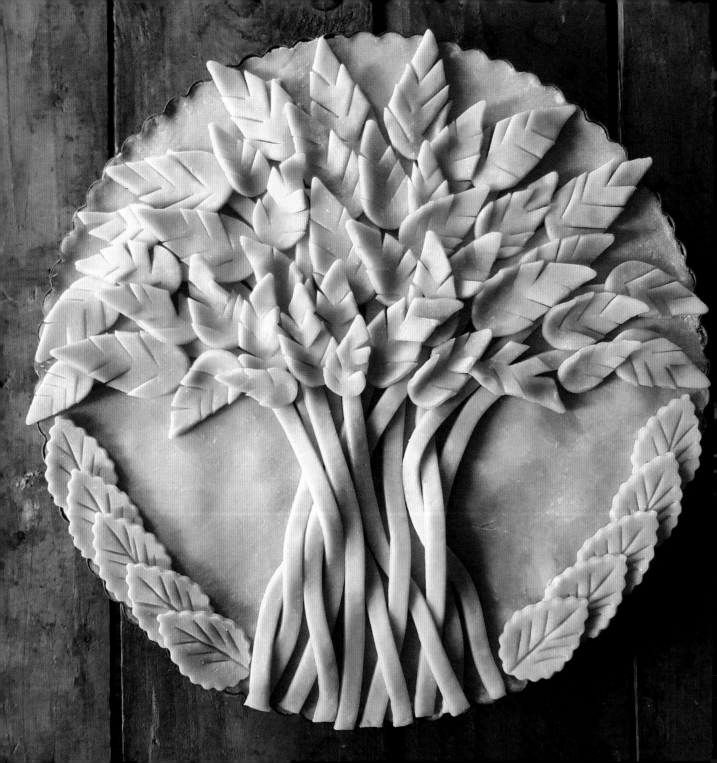

# THANKSGIVING PIE

*This pie has been a hit every time I have served it. It represents all that is good and comforting about Thanksgiving, with the harvest gathered up and time to enjoy comfort food. I designed it as a sheaf of grain; however, a number of people have referred to it as the "Tree of Life." In any case, everyone seems to find it attractive, and it's not too difficult to make. I usually use this decoration for an apple pie, but you can use the filling of your choice.*

1 prepared shell with bottom crust and filling of your choice (page 26) in a tart pan with fluted edge and no lip

TOP CRUST

Two recipes Basic Pie Dough (page 14)

SPECIAL EQUIPMENT

Ruler

Rolling cutter

Two different-sized smooth-edged drop-shaped cookie cutters

Scissors

Serrated-edge leaf cookie cutter

Paring knife

Small artist's paintbrush

EGG WASH

One egg, beaten with a few drops of water

Keep your prepared pie shell with filling in the refrigerator. Roll out both batches of dough into disks about 13 inches (33 cm) in diameter and ⅛ inch (3 mm) thick. Transfer to lightly floured pastry lifters and chill in the freezer for 15 to 30 minutes. Transfer to your lightly floured work surface or to a cutting mat and proceed as directed.

**1.** Cut 12 strips ¼ to ½ inch (8 to 12 mm) wide from one of the disks, using the ruler and rolling cutter.

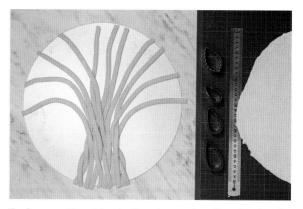

**2.** Arrange the strips in the shape of stalks of a sheaf of grain. Some of the strips should overlap at the bottom to give a random appearance.

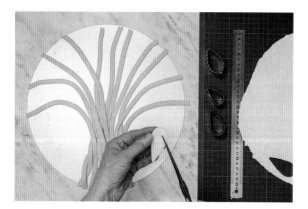

**3.** Cut out grain heads using the different-sized drop cutters, then with the scissors, cut slits in one side of the drop to give them the appearance of heads of grain.

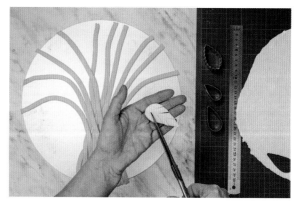

**4.** Turn the drop over in your hand and cut slits in the other side. Repeat with all of the other heads of grain.

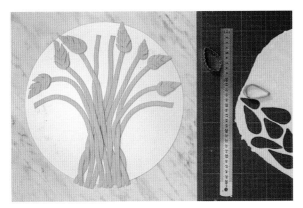

**5.** Continue cutting and slitting more of the heads of grain, using the smooth-edged drop cutter. Place the heads on the ends of the stalks at irregular angles.

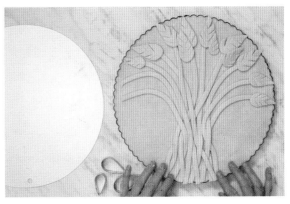

**6.** Place the second dough disk on the prepared pie shell with filling and press the edges to remove the excess. Transfer the stalks and heads of grain to the top crust.

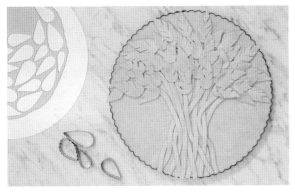

**7.** Continue adding heads to the stalks until the whole top is pleasingly full, as in the picture above.

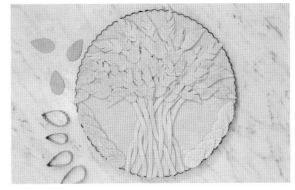

**8.** Using the serrated-edged leaf cutter, cut out 10 leaves. Emboss veins into them using the paring knife to create a pattern as shown in the picture above. Arrange them along the right and left bottom edges, five on each side as shown.

Place the whole pie in the refrigerator for at least 30 minutes. Preheat the oven to 400°F (200°C) with the rack in the bottom position.

Before baking, return the pie to the work surface. Using the small paintbrush, carefully apply the egg wash to the top crust. Place the pie in the oven and bake as directed (see page 32). If the decorations begin to brown excessively, loosely cover the pie with a sheet of aluminum foil or a pie shield. Remove from the oven and let cool on a cooling rack.

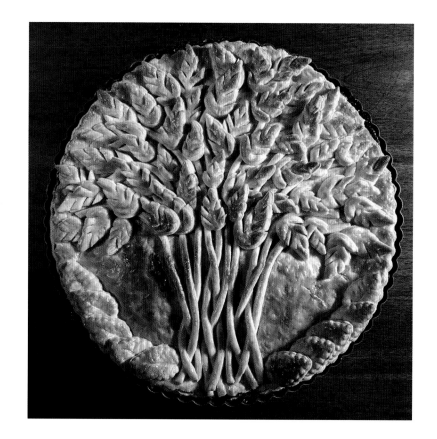

# Advanced Projects

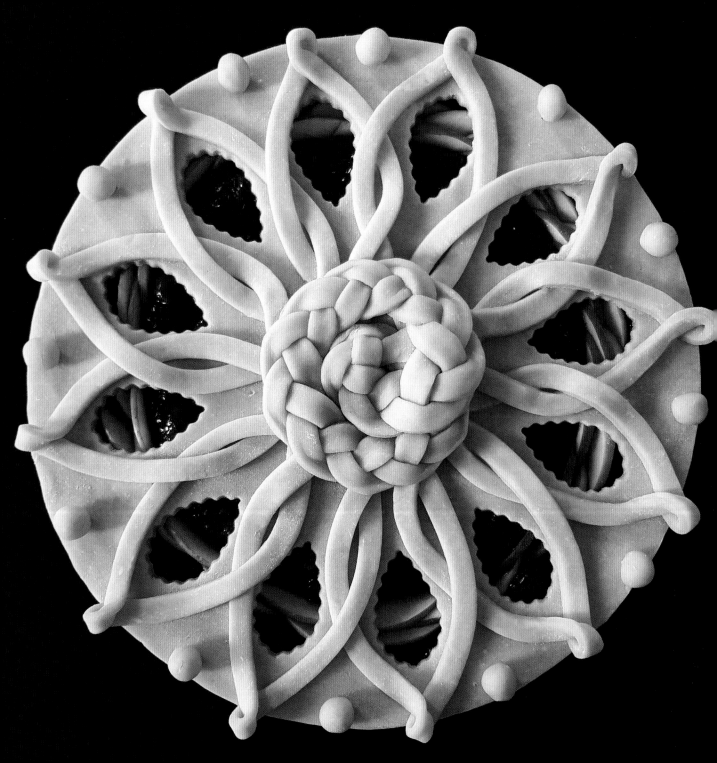

# GOTHIC ROSE WINDOW

*When I was young, I took many trips to Paris with my family. These trips had strong and lasting effects on my tastes and aesthetic appreciation. Some of my most memorable experiences were standing inside the Notre Dame Cathedral in Paris in 1975 and watching the sun stream through the stunning stained-glass windows. This design is my commemoration of the famous north rose window, which thankfully was not damaged in the terrible fire that recently destroyed so much of this noble building.*

*Although this design is somewhat difficult to make, it never ceases to impress and delight guests. I use a wild cherry filling embellished with very thin slices of red and green apples with the skins left on, arranged inside the periphery of the pie.*

1 prepared pie shell with bottom crust and cherry filling (page 29)

1 large red apple (such as Red Delicious) and 1 green (Granny Smith) apple

TOP CRUST

2 recipes Basic Pie Dough (page 14)

SPECIAL EQUIPMENT

1 copy of the rose window template (page 158)

Scissors

Scalpel or craft knife

Sharp paring knife

Rolling cutter

Ruler

1 by 1½-inch (2.5 by 4-cm) serrated leaf cookie cutter

Small artist's paintbrush

EGG WASH

1 egg, beaten with a few drops of water

Keep your prepared pie shell with filling in the refrigerator. Print the template and cut out with scissors as shown in step 1.

Roll out one batch of dough into a round disk about 12 inches (30 cm) in diameter and ⅛ inch (3 mm) thick. Roll out the second batch of dough into a 12-inch-long (30-cm) sheet of the same thickness. Dust each with a soft brush to remove any excess flour. Transfer the long sheet to a lightly floured pastry lifter and put in the refrigerator to chill. Proceed as directed with the round disk.

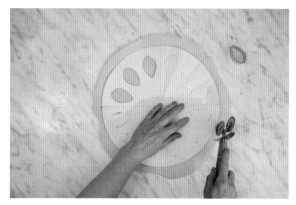

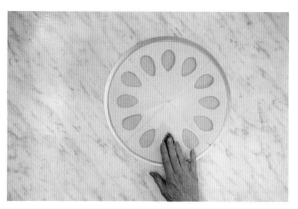

**1.** Place the template over the dough disk and cut the outer edge to about ¼ inch (6 mm) larger than the pie pan you're using. Using scissors or a scalpel, cut out the openings in the template as shown.

**2.** Place the serrated leaf cookie cutter in the center of the template cutouts and press through the dough to cut out the openings.

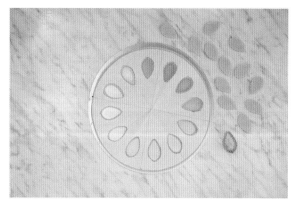

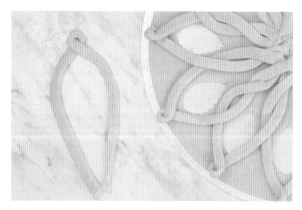

**3.** Continue until all the openings are cut out.

**4.** Transfer the long dough sheet from the refrigerator to your work surface and, using the rolling cutter, cut out 12 strips ⅜ inch (10 mm) wide and 12 inches (30 cm) long. Fold these as shown and begin placing them around the openings in the top crust.

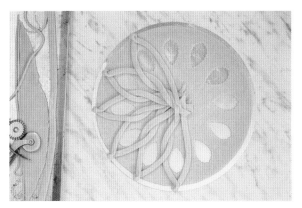

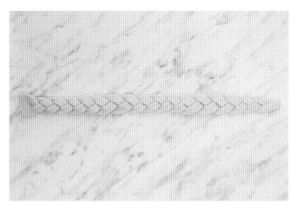

**5.** Continue folding and placing the strips around the top crust. If the strips begin to get too soft, place them in the refrigerator or freezer until they firm up. When finished, trim off the inner ends of the strips to create a smooth center surface.

**6.** Gather up the remaining dough fragments and press them together. Roll out a strip at least 18 inches (45 cm) long and cut three strips about ⅜ inch (10 mm) wide, then braid them together. The braid should be about 12 inches (30 cm) in length.

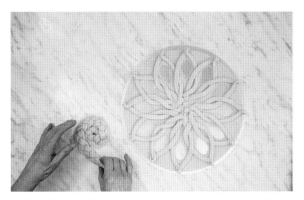

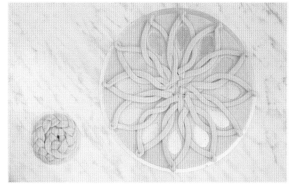

**7.** Roll the braid together into a spiral to create a "bun."

**8.** Tuck the end of the braid under the bun so it's neat and smooth.

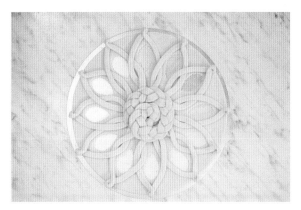

**9.** Place the finished bun in the middle of the crust over the cut ends of the strips. Place the finished top crust in the freezer until firm.

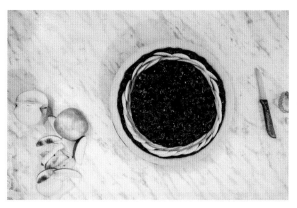

**10.** Place the prepared pie shell with cherry filling on your work area and, using a sharp knife, cut thin slices or wedges of apple. Place the green slices toward the outside and the red slices on the inside of the green slices.

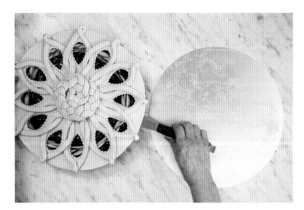

**11.** Transfer the crust to the top of the prepared pie shell with filling.

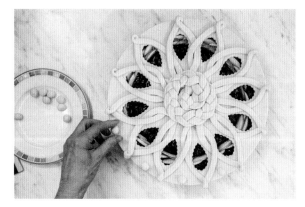

**12.** Cut out small spheres from the leftover dough and form them into balls about ½ inch (12 mm) in diameter. Place them around the periphery, centered between the ends of the folded strips as shown.

Place the prepared pie in the refrigerator for 30 minutes. Preheat the oven to 400°F (200°C) with the rack in the bottom position.

Before baking, return the pie to the work surface. Using the small paintbrush, carefully apply the egg wash to the design pieces. Place the pie in the oven and bake as directed (see page 32). If the decorations begin to brown excessively, loosely cover the pie with a sheet of aluminum foil or a pie shield. Remove from the oven and let cool on a cooling rack.

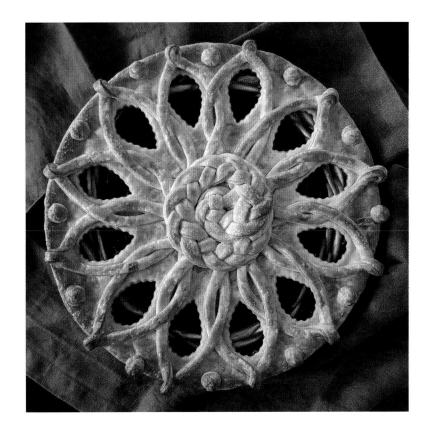

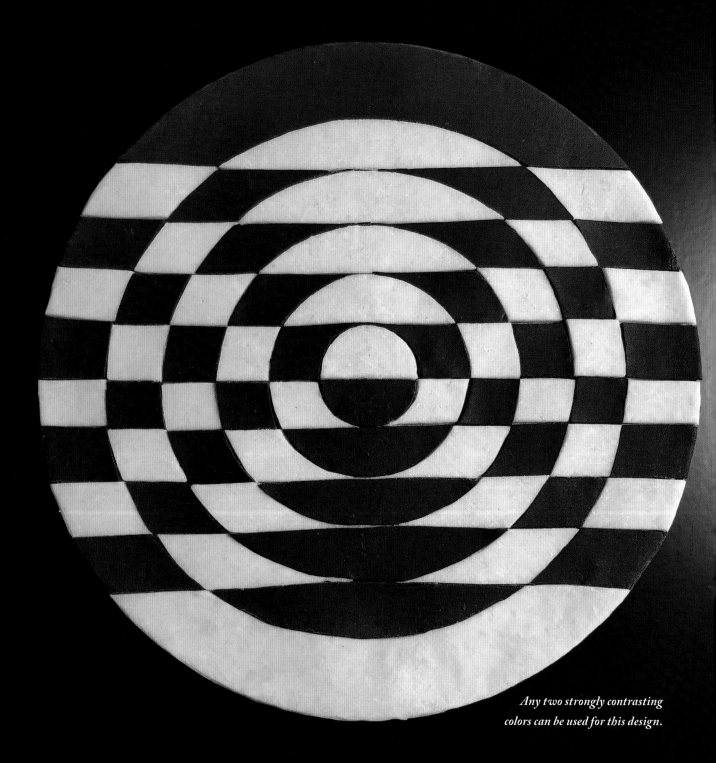

*Any two strongly contrasting colors can be used for this design.*

# BICOLOR GEOMETRIC DESIGN
# INSPIRED BY BAUHAUS

## MAKES ONE (13-INCH/33-CM) PIE

*One hundred years ago, Walter Gropius founded the Bauhaus University, Weimar, a school of artistic creativity that had an enormous influence on both the fine arts and applied design. In commemoration of this important event, I created this design. It's basically a set of concentric circles cut into parallel tangential sections with alternating brown and white segments. I suggest a filling of precooked wild cherries with chocolate bits (page 29), but any filling can be used that is compatible with the chocolate crust.*

*This design may appear difficult but requires only diligence in accurately cutting the template and the dough. The template can be copied and enlarged to fit the desired diameter you choose for your pie.*

1 prepared pie shell with bottom crust and smooth filling of your choice (page 26)

### TOP CRUST

1 recipe Basic Pie Dough (page 14)

1 recipe contrasting color pie dough (page 18)

### SPECIAL EQUIPMENT

Two copies of the geometric template (page 159)

Straight pins

Scalpel or craft knife

Small artist's paintbrush

### EGG WASH

1 egg, beaten with a few drops of water

Keep your prepared pie shell with filling in the refrigerator. Roll out both batches of dough into round disks about 12 inches (30 cm) in diameter and no more than ⅛ inch (3 mm) thick to assure that the crust doesn't become too heavy and is easy to cut smoothly.

Place the basic pie disk and the colored disk on pastry lifters, and put in the refrigerator to chill. As you're working, if the dough begins to soften excessively, return the dough disks and stencils to the refrigerator or freezer for a short time.

Once all of the segments are cut, the stencils and pins can be removed. It's then a good idea to check that all of the segments are cleanly cut out and can be lifted out. It may be necessary to chill the dough once again.

Now the fun part begins. Following the photographs for reference, the colored and white segments are exchanged so that the colors alternate. In this manner, two individual and identical crusts are created, which is ideal if you need two pies.

**1.** Pin a stencil on top of both disks of dough. Then place the dough on a thin metal pastry lifter (not visible here because it is smaller than the dough).

**2.** First, the concentric circles are cut out with a scalpel. Then the horizontal lines can be cut using a straight edge.

**3.** The stencil and pins are removed and the work can progress.

**4.** Alternating white and colored segments are exchanged and pressed lightly together.

**5.** Continue following the pattern in this manner, and gradually, two top crusts are created.

**6.** By rotating one of the disks 180 degrees, the two crusts become identical.

Preheat the oven to 400°F (200°C) with the rack in the bottom position.

Carefully wrap the extra top crust with plastic wrap; it can be kept up to 2 weeks in the freezer. Place the other finished top crust in the freezer until it's firm, and then carefully slide it onto the prepared pie shell with filling. If the individual segments move, they can be corrected before baking. Center the crust while it's still firmly frozen so that it doesn't become distorted. Using the small paintbrush, carefully apply egg wash only to the white parts of the crust. Place the pie in the oven and bake as directed (see page 32). If the top crust begins to brown excessively, loosely cover the pie with a sheet of aluminum foil or a pie shield. Remove from the oven and let cool on a cooling rack.

# WILLOW LEAVES ON A WEAVE

## MAKES ONE (10 TO 11-INCH/25 TO 28-CM) PIE

*This design is especially appropriate for late summer and fall when leaves begin to fall and acorns are dropping to the ground. I have used this top crust on apple, cherry, and peach pies, but it can be used on any pie that needs a top crust. It requires some dexterity when weaving the background as well as accurate hand cutting and embossing of the willow leaves. The other leaves and acorns are cut out using cookie cutters.*

1 prepared pie shell with bottom crust and filling of your choice (page 26)

**TOP CRUST**

3 recipes Basic Pie Dough (page 14)

**SPECIAL EQUIPMENT**

Ruler

Scalpel or craft knife

Rolling cutter

Scissors

One copy each of the willow leaf templates or willow leaves from the garden (pages 160–161)

Apple or birch leaf cookie cutter

Acorn cookie cutter

¾-inch (4-cm) small flower cookie cutter

Small artist's paintbrush

**EGG WASH**

1 egg, beaten with a few drops of water

Keep your prepared pie shell with filling in the refrigerator. Roll out all three batches of dough into disks about ⅛ inch (3 mm) thick and 1 inch (2.5 cm) larger in diameter than the pie pan you're using. Dust with a soft brush to remove any excess flour. Transfer the disks to lightly floured pastry lifters and chill in the refrigerator for at least 15 minutes.

Place two disks on your work surface. Using the ruler and rolling cutter, cut them into parallel strips about ½ inch (12 mm) wide. Proceed as directed.

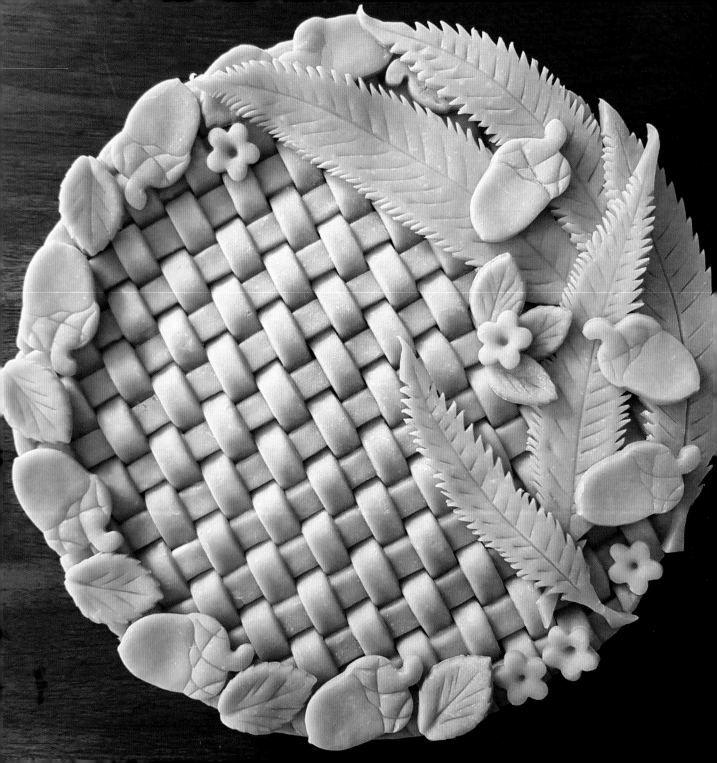

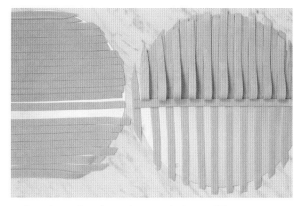

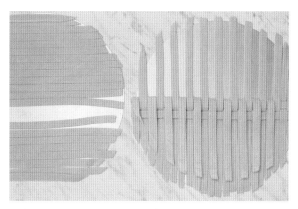

**1.** Lay the strips down in a vertical row. Flip every other strip back on itself. Place a single strip horizontally in the middle across the row and perpendicular to the straight strips.

**2.** Flip the strips back down flat across the perpendicular strip. Lay a second strip across the flipped-back strips. Flip the second set of every other strip back on itself in the opposite direction over the perpendicular strip.

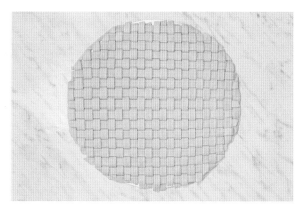

**3.** Repeat this process, adding new perpendicular strips until the sheet is fully woven as shown. Keep tightening up the rows as you work down and chill the strips if they get too soft. When finished, place the woven sheet in the refrigerator.

**4.** Lay the third dough disk on your cutting mat or work surface. Cut out the willow leaf templates with scissors. Begin cutting 5 willow leaves with a scalpel, using the templates or a leaf from the garden as a guide.

**5.** Carefully serrate the edges of the willow leaves with the knife, leaving the petiole or stem as it is. Make one straight cut and then a second at a 30-degree angle.

**6.** Remove the tiny triangular piece of dough for each serration using a scalpel.

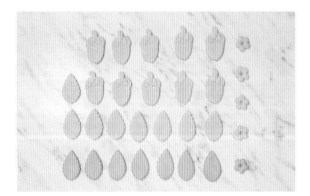

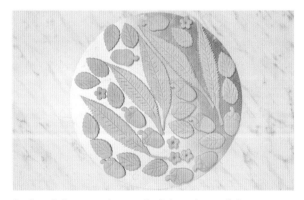

**7.** Cut out 15 apple leaves, 10 acorns, and 5 flowers using the cookie cutters.

**8.** Carefully smooth out all of the edges of the nonserrated leaves, flowers, and acorns.

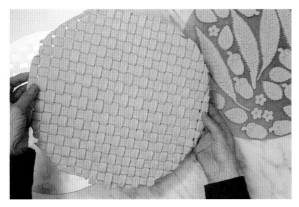

**9.** When frozen, the woven sheet is very stiff and can be easily handled and transferred to the work area or directly to the prepared pie shell with filling.

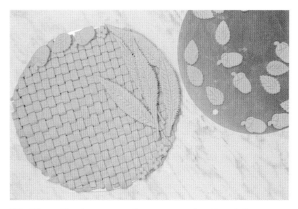

**10.** Place the leaves on the woven sheet and then begin placing the acorns and flowers around the periphery. See the photo on page 132 for exact placement of each element.

If you prepared the complete top crust on a pastry lifter, place it in the freezer before transferring to the prepared pie shell with filling. When frozen, it will stick together and can be easily slid onto the pie shell.

If you placed the woven disk on the prepared pie shell with filling, chill it in the refrigerator for at least 30 minutes.

Preheat the oven to 400°F (200°C) with the rack in the bottom position.

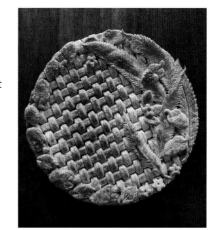

Before baking, return the pie to the work surface. Using the small paintbrush, carefully apply the egg wash to the top and replace any decorations that might have moved. Place the pie in the oven and bake as directed (see page 32). If the decorations begin to brown excessively, loosely cover the pie with a sheet of aluminum foil or a pie shield. Remove from the oven and let cool on a cooling rack.

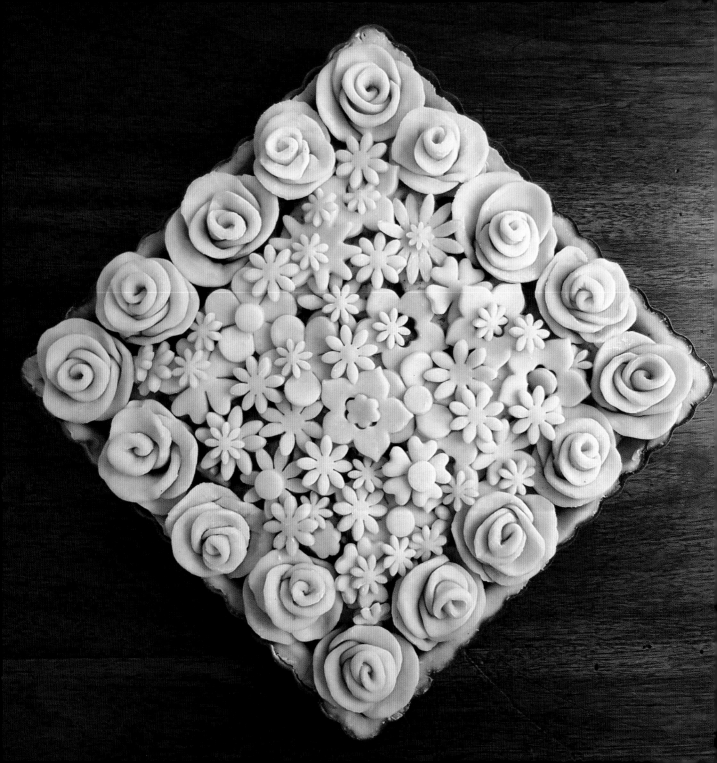

# THE SQUARE ROSE GARDEN

*This is the perfect pie to serve in summer. While the design is ideal for an apple pie, there's no reason not to use it with other fruits or berries. I enjoy using the square form because it's a nice surprise for guests who expect a round pie.*

*Making the roses takes some skill and patience, but it's not difficult to learn with a bit of practice.*

1 prepared pie shell with bottom crust and filling of your choice (page 26) in a 9-inch (23-cm) square pie or tart pan

## TOP CRUST

2 to 3 recipes Basic Pie Dough (page 14)

2 tablespoons melted butter

## SPECIAL EQUIPMENT

1 shot glass or 2-inch (5-cm) circle cookie cutter

Sharp, thin knife

8 to 12 flower cookie cutters of different shapes and sizes, up to 1½ inches (4 cm) wide

Small artist's paintbrush

## EGG WASH

1 egg, beaten with a few drops of water

Keep your prepared pie shell with filling in the refrigerator. Roll out both batches of dough into round disks about 12 to 13 inches (30 to 33 cm) in diameter and ⅛ inch (3 mm) thick. Dust with a soft brush to remove any excess flour. Transfer the disks to lightly floured pastry lifters and place them in the refrigerator to chill for 15 minutes.

Remove one of the disks from the refrigerator and place it on your work surface. Proceed as directed.

**1.** Using a shot glass or 2-inch circle (5-cm) cookie cutter, cut circles from the first dough disk. Turn them over so the clean edge is face up, and smooth it out with your finger.

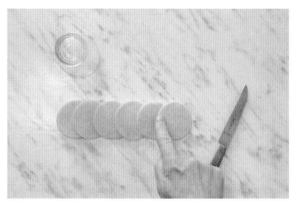

**2.** Arrange six circles, overlapping them by about one-third. Press each of the overlapping circles together using your finger as shown.

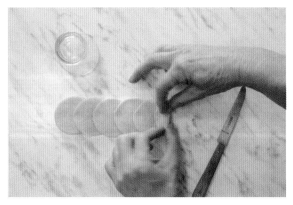

**3.** Starting with the top one, roll the circles together into a tight cylinder.

**4.** Two roses can be made from each roll.

**5.** Use a sharp knife to carefully cut the roll into two halves.

**6.** Press the ends of the circles together on one end of the cylinder.

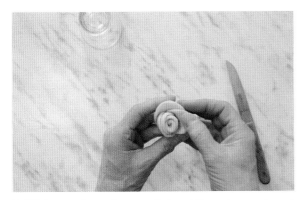

**7.** With your fingertips, gently bend the edges outward to create the petals.

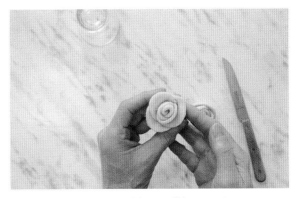

**8.** With a little practice, it's possible to make very convincing-looking roses. Repeat this process. You'll need a total of 16 roses.

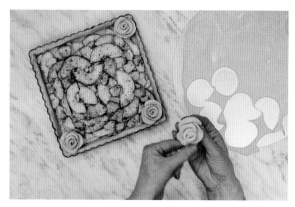

**9.** Remove the pan with the filling from the refrigerator, drizzle melted butter over the apples, and place a rose in each of the corners of the pan.

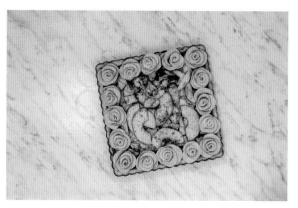

**10.** Add 3 more roses between each of the corner roses.

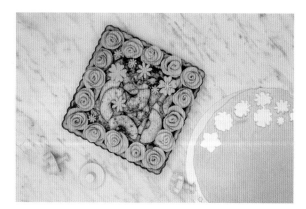

**11.** When you've used up all the dough from the first disk, remove the second one from the refrigerator and begin cutting out different-sized flowers with the cookie cutters and add them to the center of the pie. Use the third dough disk as needed.

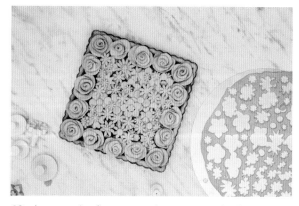

**12.** Arrange the flowers so they are evenly distributed and in a nice and attractive arrangement.

Place the prepared pie in the refrigerator for at least 30 minutes. Preheat the oven to 400°F (200°C) with the rack in the bottom position.

Before baking, return the pie to the work surface. Using the small paintbrush, carefully apply the egg wash. Place the pie in the oven and bake as directed (see page 32). If the decorations begin to brown excessively, loosely cover the pie with a sheet of aluminum foil or a pie shield. Remove from the oven and let cool on a cooling rack.

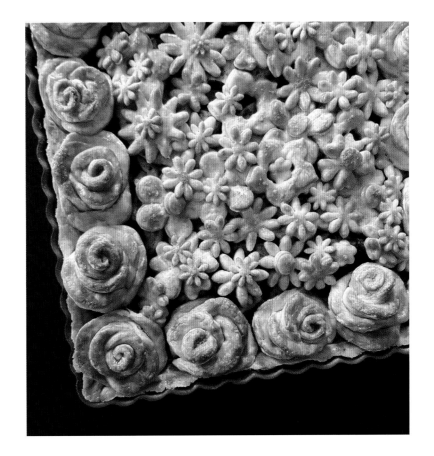

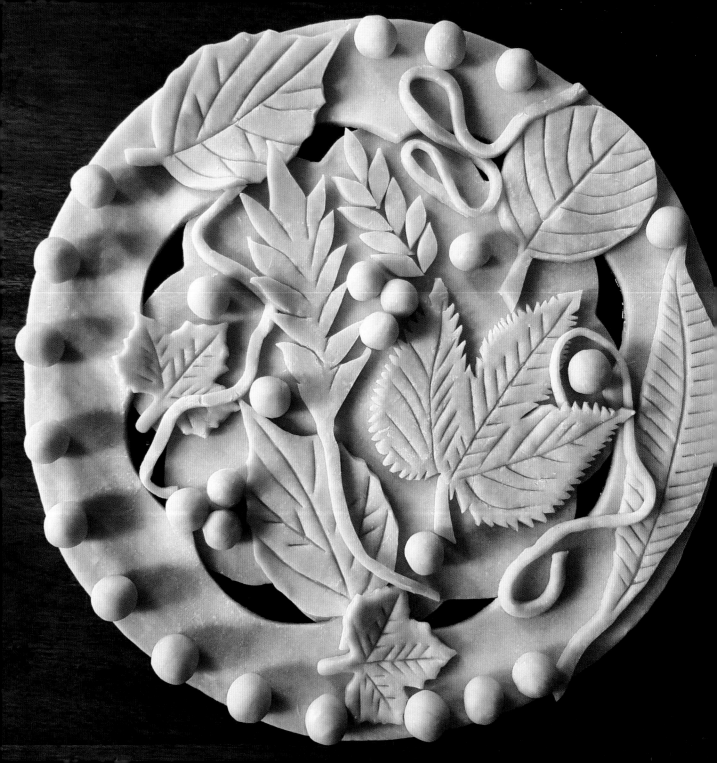

# OCTOBER LANDSCAPE

*This is my favorite design of all. It represents everything good and plentiful that we celebrate in autumn. It's a time for real comfort food, and that's exactly what this pie suggests.*

1 prepared pie shell with bottom crust and apple filling (page 27)

**TOP CRUST**
3 recipes Basic Pie Dough (page 14)

**SPECIAL EQUIPMENT**
1 copy each of the top crust templates (pages 162–163)
1 copy each of the five leaf templates (pages 164–165)
Scissors
Scalpel or craft knife
Pins
1 maple leaf cookie cutter
Paring knife
1¾-inch (4.5-cm) circle cookie cutter
Small artist's paintbrush

**EGG WASH**
1 egg, beaten with a few drops of water

Keep your prepared pie shell with filling in the refrigerator. Roll out 3 batches of dough into round disks ⅛ inch (3 mm) thick and 1 inch (2.5 cm) larger than the diameter of the pie pan you're using. Dust each disk with a soft brush to remove any excess flour. Transfer the disks to lightly floured pastry lifters and place them in the refrigerator to chill for 15 minutes.

Place 2 disks on your work surface and proceed as directed.

**1.** Place the 11-inch template on top of one crust, and cut around the outer edge so the diameter matches your pie pan. Pin the template to the disk and cut out the inner shape using a scalpel, keeping the edges as clean and smooth as possible.

**2.** If necessary, smooth all of the cut edges with your fingers. Place the cut-out part in the refrigerator for later use.

**3.** Pin the 8-inch template to the second disk and cut out the shape around the template as shown.

**4.** As you can see by comparing this picture with the one above it, this inner part has a different profile than the part cut out with the first template. Place the outer part of this disk in the refrigerator or freezer for later use. This ring can be used as an attractive border for a fruit pie, leaving the middle open to show off the fruit.

**5.** Place the outer circle over the inside, turned so that both circles line up, as in the picture shown, leaving small openings between the parts. Place in the refrigerator or freezer until needed.

**6.** While the top crust is chilling, begin cutting out the six leaves from the third dough disk using the stencils and a scalpel. You will also need two small maple leaves cut out using the cookie cutter. Once all the leaves are cut out, place all in the refrigerator or freezer.

**7.** To serrate the edge of the leaves, begin by making a small cut and then a second cut at a 30-degree angle to the first cut. Making these cuts makes it easier to remove the small triangular pieces. When finished, place the leaves back in the refrigerator or freezer.

**8.** Use the back of a paring knife to emboss the veins into the leaves as shown.

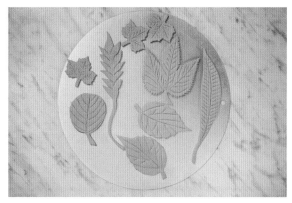

**9.** These are the eight leaves needed for this design. Smooth the edges of the leaves if necessary. Place in the refrigerator or freezer.

**10.** Begin adding the leaves as decorations, using the finished pie picture on page 142 as a guide.

**11.** Use the third dough disk to cut out circles using the ¾-inch (2-cm) circle cutter and roll them into spheres.

**12.** You will need 26 of the spheres in total. Place them on the finished pie as shown on page 142.

Cut out three thin "vines," about 8 inches (20 cm) long, from the remaining dough. Add them to the top of the leaf decorations as shown.

Place the prepared pie in the freezer for 30 minutes. Preheat the oven to 400°F (200°C) with the rack in the bottom position.

Before baking, return the pie to the work surface. Using the small paintbrush, carefully apply the egg wash to make sure it's applied evenly to all areas. It's a good idea to hold the spheres and other small decorations in place with egg wash to keep them from falling off.

Place the pie in the oven and bake as directed (see page 32). If the decorations begin to brown excessively, loosely cover the pie with a sheet of aluminum foil or a pie shield. Remove from the oven and let cool on a cooling rack.

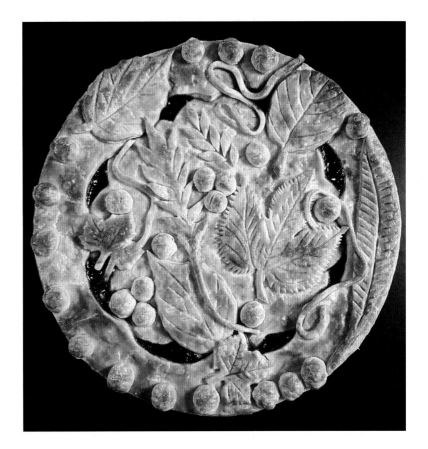

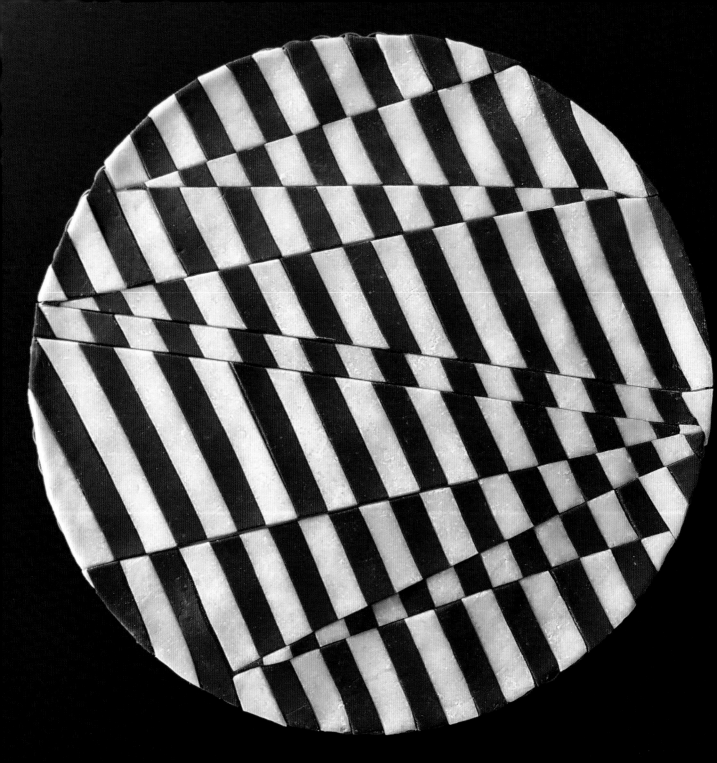

# A TEAR IN THE FABRIC OF SPACE-TIME

## MAKES ONE (13-INCH/33-CM) PIE

*Albert Einstein's general theory of relativity states that time and space are woven together to form a fabric. The fabric is supposed to be smooth and unbroken, but I like to fantasize that it could get torn, and, at the point of the tear, magic can happen. In the case of this pie, the magic happens underneath the tear, when you find a warm filling of wild cherries, peaches, or apples.*

*This crust is rather demanding to make, as it requires two colors of dough to be cut into strips that have to be stuck together. The dough must be warm for them to stick together but then must be cooled so that they stiffen but don't break apart. The result is so dramatic that the effort is definitely worth it. As noted above, you can use this crust on almost any pie as long as the filling can form a smooth surface. The slices I have made are simply suggestions. You can optimize this according to your own preference by slicing in different patterns.*

1 prepared pie shell with bottom crust and filling of your choice (page 26)

### TOP CRUST

2 recipes Basic Pie Dough (page 14)

1 recipe Red (Beet) Pie Dough (page 20) or color of your choice

### SPECIAL EQUIPMENT

Ruler

Rolling cutter

Plastic wrap

Long, thin palette knife

Small artist's paintbrush

### EGG WASH

1 egg, beaten with a few drops of water

Keep your prepared pie shell with filling in the refrigerator. Roll out all three batches of dough into disks about 13 inches in diameter and ⅛ inch (3 mm) thick. Place one disk of white dough on the prepared shell with filling and cleanly press off the edges and place in the refrigerator to chill.

Using the ruler and the rolling cutter, cut the other white sheet and the colored sheet into strips ½ inch (12 mm) wide. Proceed as directed.

**1.** Alternate the strips to create a zebra-stripe pattern. The dough must be at a warm room temperature, not chilled.

**2.** Gently press the strips together, cover with plastic wrap, and roll firmly and evenly with the rolling pin.

**3.** Carefully peel back the plastic wrap and remove, making certain that the strips do not stick to the plastic. Chill the disk in the freezer for at least 15 minutes.

**4.** When the dough has firmed up a bit, trim off the edges with the rolling cutter to make a clean disk.

**5.** Place the ruler on the disk at a 45-degree angle. Using the rolling cutter, cut through the disk, making certain that the cut goes from one end through to the other.

**6.** Replace any small pieces that were loosened while cutting. If any pieces get damaged, you can use some of the excess dough from the original cutting for repair.

**7.** Carefully slide the right half of the disk 1 inch (2.5 cm) down so the opposite-colored lines are aligned. For the most dramatic effect, the alignment must be very accurate.

**8.** Continue making random slices at random angles and sliding the parts one line up or down so that an interesting pattern appears. There are no rules to how these should be arranged, but the individual slices should not be too thin or they will fall apart.

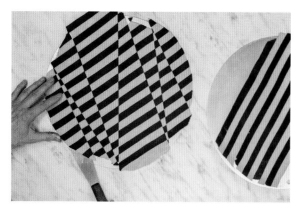

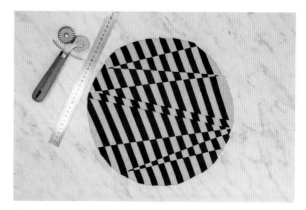

**9.** Using a long, thin knife or palette makes it easy to slide the cut sections.

**10.** Continue cutting and sliding the disks, chilling in between as needed. Trim the edges to create a perfect disk to fit the size of the pie pan.

Freeze the disk for at least 30 minutes and then slide it carefully onto the top crust of the prepared pie shell with filling. Align carefully over the pan. Preheat the oven to 400°F (200°C) with the rack in the bottom position.

Before baking, return the pie to the work surface. Use the small paintbrush to carefully apply the egg wash to the white areas only, or, for greater contrast, don't use at all. Place the pie in the oven and bake as directed (see page 32). If the decorations begin to brown excessively, loosely cover the pie with a sheet of aluminum foil or a pie shield. Remove from the oven and let cool on a cooling rack.

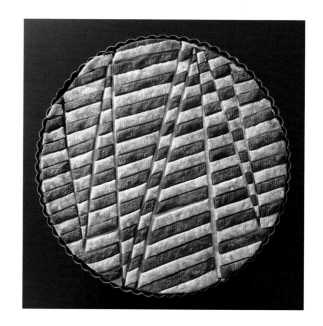

# Templates

Make a copy of your templates according to the
size of the pie you're making.

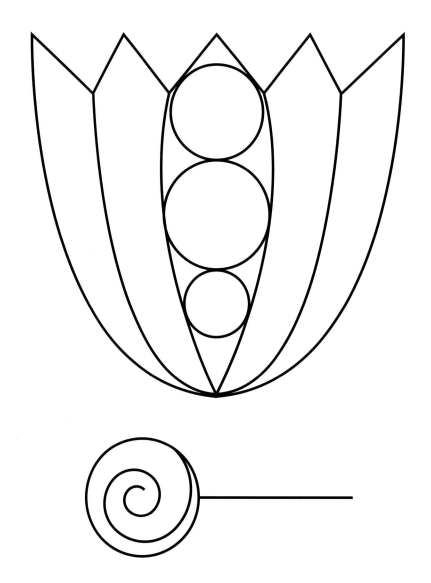

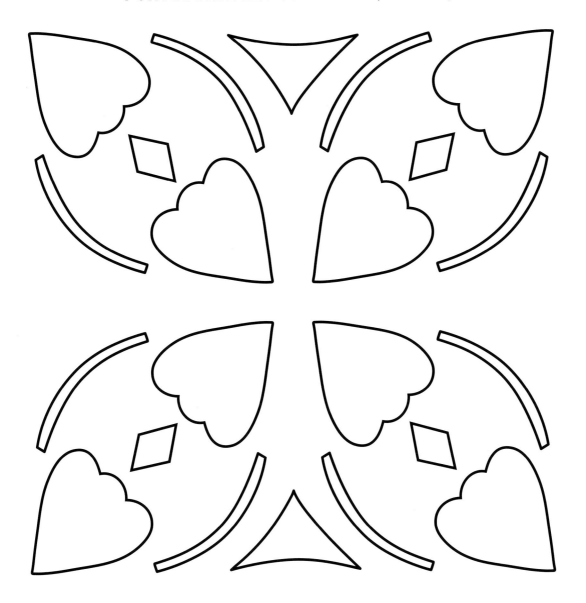

# GINKGO BILOBA (PAGE 101)

# WILLOW LEAVES ON A WEAVE (PAGE 131)

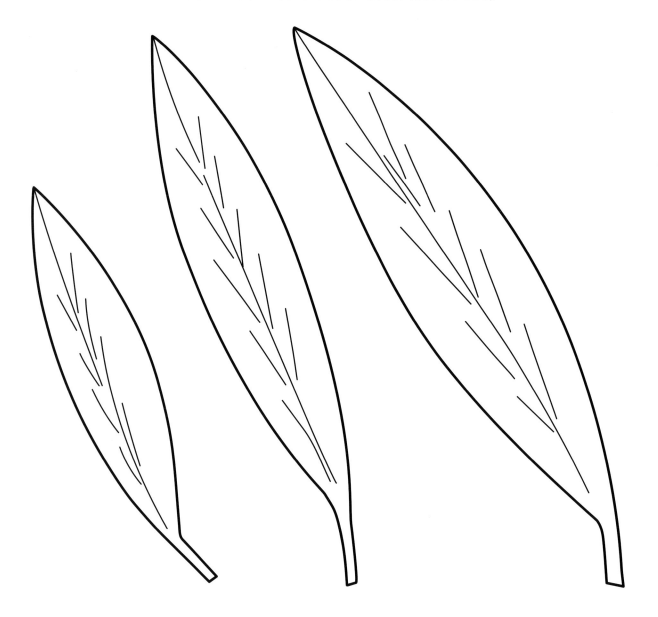

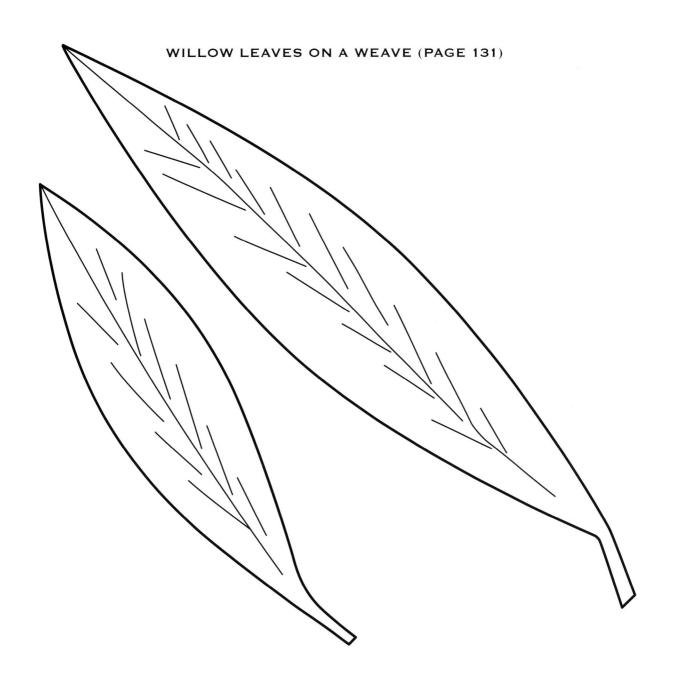

WILLOW LEAVES ON A WEAVE (PAGE 131)

11 inches

8 inches

# Resources

GERMANY

**Amazon** (baking equipment of all kinds) • www.amazon.de

**Aurora Mühlen GmbH** (flour) • www.aurora-mehl.de

**Braun** (food processors) • www2.braunhousehold.com/de-de

**Kaiser Baking Pans** • www.kochform.de/Kaiser-Backformen.htm

**Städter GmbH** (everything for baking, including cookie cutters) • www.staedter.de

UNITED STATES

**Amazon** (cutters, knives, rolling pins, and almost everything else) • www.amazon.com

**KitchenAid** (stand mixers) • www.kitchenaid.com

**Joseph Joseph** (rolling pins) • www.josephjoseph.com/en-us

**Williams Sonoma** • www.williams-sonoma.com

UNITED KINGDOM

**Divertimenti** • www.divertimenti.co.uk

**Lakeland** (cooking and baking products) • www.lakeland.co.uk

**John Lewis** • www.johnlewis.com

# Acknowledgments

This book would not have been possible without the unceasing help and support of my husband and friend, Dr. C. Bruce Boschek.

The idea of publishing a book about my artistically decorated pies stems from Irene Goodman, and I am indebted both to her and to Kim Perel for help getting this project off the ground.

I would like to thank everyone at Andrews McMeel Publishing, and in particular my editor, Jean Lucas, for patiently taking me through the steps of writing my first book. Holly Swayne (art director and designer), Elizabeth Garcia (production editor), and Samantha Jones (editing assistant) deserve my gratitude and praise for helping this book take shape.

Finally, thanks go to my mother-in-law, Miriam Boschek, for her recipe that serves as the basis for my pie dough. Her apple pie filling, unpretentious as it is, has been a joy to make, serve, and eat for many years. This dear person won many prizes for her pies and was an inspiration for many cooks and bakers. It was her pie recipes, made later by her son, that inspired me to make my first pie.

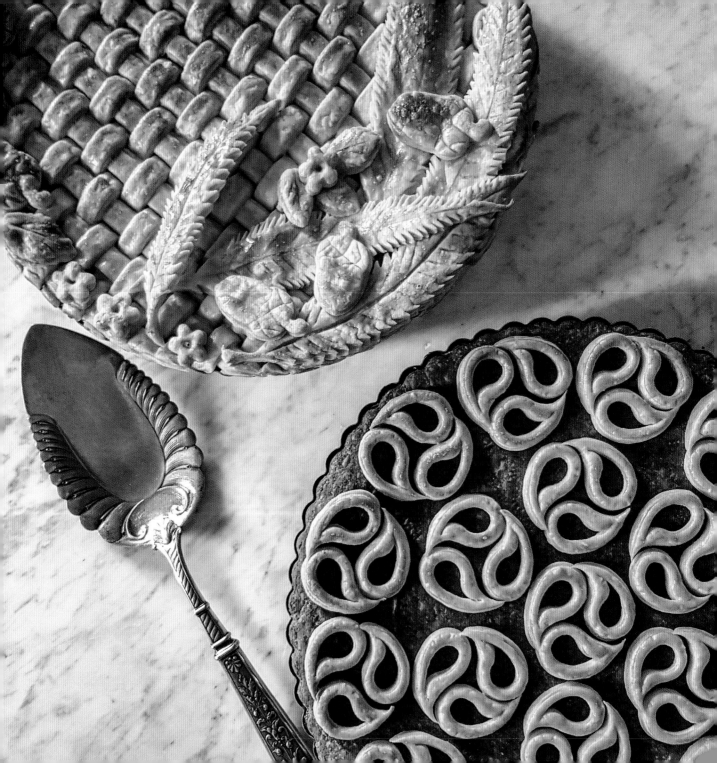

# METRIC CONVERSIONS AND EQUIVALENTS

## Volume

| | |
|---|---|
| ¼ teaspoon | 1 milliliter |
| ½ teaspoon | 2.5 milliliters |
| ¾ teaspoon | 4 milliliters |
| 1 teaspoon | 5 milliliters |
| 1¼ teaspoons | 6 milliliters |
| 1½ teaspoons | 7.5 milliliters |
| 1¾ teaspoons | 8.5 milliliters |
| 2 teaspoons | 10 milliliters |
| 1 tablespoon (½ fluid ounce) | 15 milliliters |
| 2 tablespoons (1 fluid ounce) | 30 milliliters |
| ¼ cup | 60 milliliters |
| ⅓ cup | 80 milliliters |
| ½ cup (4 fluid ounces) | 120 milliliters |
| ⅔ cup | 160 milliliters |
| ¾ cup | 180 milliliters |
| 1 cup (8 fluid ounces) | 240 milliliters |
| 1¼ cups | 300 milliliters |
| 1½ cups (12 fluid ounces) | 360 milliliters |
| 1⅔ cups | 400 milliliters |
| 2 cups (1 pint) | 480 milliliters |
| 3 cups | 720 milliliters |
| 4 cups (1 quart) | 0.96 liter |
| 1 quart plus ¼ cup | 1 liter |
| 4 quarts (1 gallon) | 3.8 liters |

## Mass

| | |
|---|---|
| ¼ ounce | 7 grams |
| ½ ounce | 14 grams |
| ¾ ounce | 21 grams |
| 1 ounce | 28 grams |
| 1¼ ounces | 35 grams |
| 1½ ounces | 42.5 grams |
| 1⅔ ounces | 47 grams |
| 2 ounces | 57 grams |
| 3 ounces | 85 grams |
| 4 ounces (¼ pound) | 113 grams |
| 5 ounces | 142 grams |
| 6 ounces | 170 grams |
| 7 ounces | 198 grams |
| 8 ounces (½ pound) | 227 grams |
| 16 ounces (1 pound) | 454 grams |
| 35.25 ounces (2.2 pounds) | 1 kilogram |

## Length

| | |
|---|---|
| ⅛ inch | 3 millimeters |
| ¼ inch | 6.25 millimeters |
| ½ inch | 1.25 centimeters |
| 1 inch | 2.5 centimeters |
| 2 inches | 5 centimeters |
| 2½ inches | 6.25 centimeters |
| 4 inches | 10 centimeters |
| 5 inches | 12.75 centimeters |
| 6 inches | 15.25 centimeters |
| 12 inches (1 foot) | 30.5 centimeters |

## COMMON INGREDIENTS AND THEIR APPROXIMATE EQUIVALENTS

1 cup uncooked white rice = 185 grams
1 cup all-purpose flour = 120 grams
1 stick butter (4 ounces • ½ cup • 8 tablespoons) = 110 grams
1 cup butter (8 ounces • 2 sticks • 16 tablespoons) = 220 grams
1 cup brown sugar, firmly packed = 213 grams
1 cup granulated sugar = 200 grams

## METRIC CONVERSION FORMULAS

| To Convert | Multiply |
|---|---|
| Ounces to grams | Ounces by 28.35 |
| Pounds to kilograms | Pounds by.454 |
| Teaspoons to milliliters | Teaspoons by 4.93 |
| Tablespoons to milliliters | Tablespoons by 14.79 |
| Fluid ounces to milliliters | Fluid ounces by 29.57 |
| Cups to milliliters | Cups by 240 |
| Cups to liters | Cups by .236 |
| Pints to liters | Pints by .473 |
| Quarts to liters | Quarts by .946 |
| Gallons to liters | Gallons by 3.785 |
| Inches to centimeters | Inches by 2.54 |

## OVEN TEMPERATURES

To convert Fahrenheit to Celsius, subtract 32 from Fahrenheit, multiply the result by 5, then divide by 9.

| Description | Fahrenheit | Celsius | British Gas Mark |
|---|---|---|---|
| Very cool | 200° | 95° | 0 |
| Very cool | 225° | 110° | ¼ |
| Very cool | 250° | 120° | ½ |
| Cool | 275° | 135° | 1 |
| Cool | 300° | 150° | 2 |
| Warm | 325° | 165° | 3 |
| Moderate | 350° | 175° | 4 |
| Moderately hot | 375° | 190° | 5 |
| Fairly hot | 400° | 200° | 6 |
| Hot | 425° | 220° | 7 |
| Very hot | 450° | 230° | 8 |
| Very hot | 475° | 245° | 9 |

Information compiled from a variety of sources, including *Recipes into Type* by Joan Whitman and Dolores Simon (Newton, MA: Biscuit Books, 1993); *The New Food Lover's Companion* by Sharon Tyler Herbst (Hauppauge, NY: Barron's, 2013); and *Rosemary Brown's Big Kitchen Instruction Book* (Kansas City, MO: Andrews McMeel, 1998).

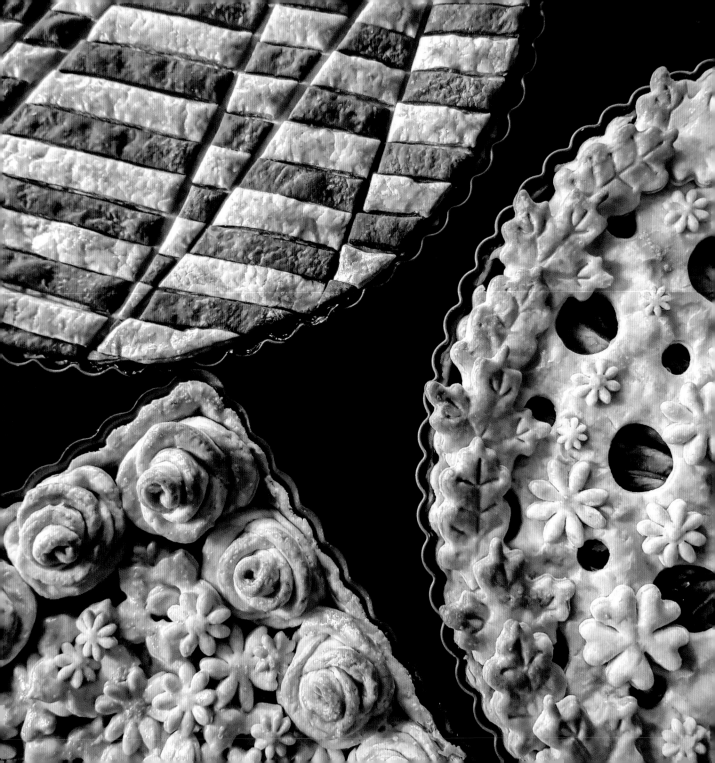

# Index